Hand Lettering

FOR BEGINNERS

Hand Lettering

FOR BEGINNERS

simple techniques. endless possibilities.

Sarah Ensign

ALPHA

Publisher Mike Sanders
Editor Brook Farling
Designer and Art Director Rebecca Batchelor
Photographer Sarah Ensign
Proofreader Polly Zetterberg
Indexer Celia McCoy

First American Edition, 2021
Published in the United States by DK Publishing
6081 E. 82nd Street, Indianapolis, IN 46250

Published in the United States by Dorling Kindersley Limited.

Library of Congress Catalog Number: 2020941348
ISBN: 978-1-6156-4980-8

Note: This publication contains the opinions and ideas of its author(s). It is intended
to provide helpful and informative material on the subject matter covered. It is sold
with the understanding that the author(s) and publisher are not engaged in
rendering professional services in the book. If the reader requires personal
assistance or advice, a competent professional should be consulted. The author(s)
and publisher specifically disclaim any responsibility for any liability, loss, or risk,
personal or otherwise, which is incurred as a consequence, directly or indirectly, of
the use and application of any of the contents of this book.

DK books are available at special discounts when purchased
in bulk for sales promotions, premiums, fund-raising,
or educational use. For details, contact:
SpecialSales@dk.com

Printed and bound in China

Author photo on page 5 © Katie Bell
All other images © Dorling Kindersley Limited

For the curious

www.dk.com

About the Author

Sarah Ensign is a hand lettering artist and creator of *ensigninsights.com* where she teaches hand lettering to thousands of people around the world. Through teaching and creative hand lettering, Sarah's goal is to share her love of life to strengthen her students, inspire their creativity as a source of happiness, and heal and uplift their spirits. She is passionate about helping others create their own happiness and finding their own self-worth through the creative process of hand lettering. You can find Sarah's hand lettering art and tutorials on Instagram (ensigninsights) and her YouTube channel (youtube.com/ensigninsights).

Acknowledgments

I would like to thank Brook Farling, my amazing editor, and the DK Alpha publishing team for appreciating my love of hand lettering and color, and recognizing the potential in me.

Thank you to my brother for starting me on this hand lettering adventure. That phone call changed everything for me.

Thank you to my husband for gifting me my first hand lettering pens and starting my unquenchable desire to accumulate all the pens.

Thank you to my supportive family for inspiring me to create and always being interested in the things I'm doing.

Thank you to my friend, Katie Bell, for the beautiful headshot. I've never looked better.

A special thanks to my wonderful lettering community for your support and encouragement, and for sharing my love of letters, colors, and pens. You fuel my passion for this beautiful art.

Finally, I'd like to thank all those who have chosen to learn from me. Thank you for asking the best questions and getting excited about lettering with me.

Dedication

To Zoey, for sleeping through the night so I could stay up and write this book. And to Gentry, for doing everything else.

Creating Basic Font Styles

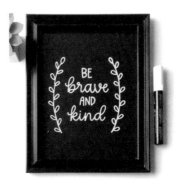

p. 98

p. 106

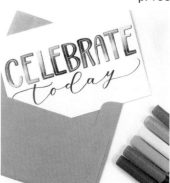

p. 114

p. 122

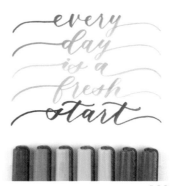
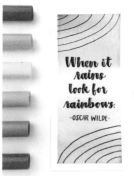

p. 130

p. 138

Getting Started

Whatever your reason may be for picking up this book, I'm so glad you're here! As we get started, I want you to always remember that the way you create right now is exactly where you need to be. Join me as we walk through the steps of learning hand lettering!

Welcome to the World of Hand Lettering

Whether you feel like you have good or bad handwriting, I want you to know that you can absolutely learn hand lettering! I'm so excited for you to join me in creating beautiful letters. I started hand lettering during a difficult time in my life when I needed something to remind me of how to be happy. It became my therapy and I looked forward to practicing it every day. Little did I know that lettering would become such a big part of my life.

One of the best things about lettering has been meeting so many other people who love lettering. So, as you begin this journey, I'm inviting you to be my lettering friend! If we could sit down at my kitchen table and letter together, I would share all of my pens with you (my husband says I have plenty of pens, but you and I know that you can never have too many) and the first thing I would tell you is to forget everything you believe about your own handwriting or artistic skills. You can learn to letter just as long as you're willing to practice!

Why should you hand letter?

Hand lettering can provide great stress relief. It's very calming and will help you slow down and focus on the details, and it will work your creative muscles as you create beautiful lettering pieces. It can be as expensive or inexpensive as you want it to be, but you can do it anywhere just as long as you have a pen and paper. Also, you may be surprised, as I was, that it can become a source of income!

Isn't hand lettering just writing in cursive?

Hand lettering is not simply handwriting or cursive. Cursive is writing in one continuous line, but hand lettering is the art of drawing individual letters by hand. Sometimes I'm told that I do my cursive wrong because I'm picking up my pen, but actually, I'm not writing in cursive! Instead of writing words in continuous strokes, with hand lettering you'll be picking up your pen between the strokes, so you'll actually be drawing the letters as opposed to writing them. You'll be learning a new skill, and as with any new skill, it will take some practice to learn the craft.

Do you need to be an artist to hand letter?

No! With practice, anyone can learn to hand letter. It may be a little challenging at first—similar to how it feels when you try writing your name with your non-dominant hand—but with enough practice it will start to feel natural and you'll begin creating beautiful lettering that you can share with your friends and family. And luckily, you don't have to learn hand lettering with your non-dominant hand!

Do you need to be right-handed to hand letter?

Absolutely not! Sometimes I'm asked by left-handers if they can still learn how to hand letter. The answer is a big "yes," of course! There are many talented hand letterers who are lefties, and the basics in this book will still work for you, even if you're a lefty. The biggest issue I notice for lefties is that they smudge the ink when they letter. There are a few things you can do to avoid smudging. First, test your pens to see how long they take to dry and then try to use pens that dry faster. You can also wait between each letter to make sure the ink is dry enough, though this can take longer, especially if you are using really inky pens. You can also angle the paper so your hand goes under the letters as you draw them, or you can letter with your hand hovering slightly above the paper. I've even seen people sketch out a word and then letter it backward! It may take some getting used to, but you'll definitely find what works for you. Lettering takes a lot of practice for both lefties and righties.

The way you CREATE right now is exactly where you need to be.

Hand Lettering Concepts

Beautiful hand lettering looks effortless, but there actually are some important concepts to understand that will help you create consistent and beautiful letters. You'll run across these terms quite a bit as you work your way through this book, and you'll see these concepts in action as you work through the practice worksheets.

The structural components of lettering

As you learn to hand letter, it's important to understand not just what makes up letters, but how they are built. These are the basic structural concepts you should understand in order to create consistent letters.

- **Baseline:** The bottom line where the letters sit.
- **Midline or x-height:** The middle line where the tops of most lowercase letters touch.
- **Cap line:** The line where the tops of ascenders and uppercase letters stop.

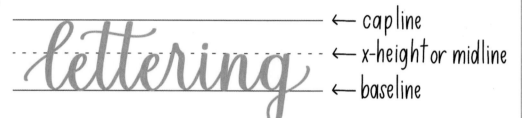

The basic components of letters

There are five basic components that make up letters.

- **Downstroke:** Where the pen goes down (the thicker strokes).
- **Upstroke:** Where the pen goes up (the thinner strokes).
- **Cross stroke:** A horizontal stroke that crosses through a vertical stroke.
- **Ascender:** The part of the letter that goes above the midline, such as for letters b, l, and k.
- **Descender:** The part of the letter that goes below the baseline, such as for letters g, p, and y.

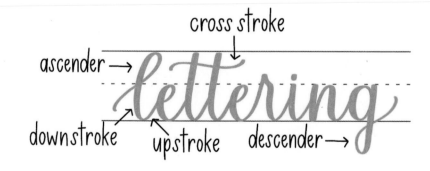

Basic font styles and types

Quite often in hand lettering you'll hear the terms *script-style fonts* and *print-style fonts*, as well as *serif* and *sans-serif*, discussed. So what are the differences?

There are two main **styles** of fonts:

- A **script-style font** is a cursive-style or calligraphy-style font.

Script

- A **print-style font** is any font where the letters are not connected.

Print

There are two main **types** of fonts:

- The letters in a **serif** font feature little tails on the letters.

SERIF

- The letters in a **sans-serif** font do not include the little tails.

SANS SERIF

Inspiration for creating your own hand lettering fonts can be found anywhere—on TV, on book covers, and even on cereal boxes! I really like combining script and print styles in lettering pieces to add more interest and make certain things stand out.

Other hand lettering terms

As you letter, you may come across terms that can often make it difficult to understand exactly what hand lettering is and what it is not. Here are some definitions that will help you understand the differences.

- **Brush Lettering** is lettering created with a paint brush or brush pen. It can also be called *brush pen lettering*.
- **Calligraphy** is the art of writing stylized letters, typically using a special tool like a pointed pen or parallel pen.
- **Modern calligraphy** is like calligraphy, but it's less formal and doesn't typically follow a specific font, so you can add your own flair.
- **Typography** is the art of creating, styling, and arranging type. This term could apply to creating a computer font or hand lettering words on a sign.

Hand Lettering Tools and Supplies

There are so many amazing tools you can use to create beautiful hand lettering, but you'll only need a few to create the projects in this book. Here are some descriptions of the basic tools and supplies you'll need.

Pens

Pens are at the foundation of hand lettering, and while you can use almost any type of pen to letter, using the right type of pen will have a big impact on your results. Here are some basic pen types to familiarize yourself with as you begin your hand lettering journey.

Brush Pens

There are both large brush pens and small brush pens. Typically, it's easier to learn lettering with small brush pens because they're a little easier to control. The nib on a brush pen—the part you put to the paper— can vary between hard and soft flexibility; soft nibs are more flexible, while hard nibs are less flexible. Neither nib type is superior to the other; it's all about preference, which means you should experiment to see which type works best for you. My favorite small brush pens are Pentel Touch, which have soft nibs. If you prefer firmer nibs, Tombow Fudenosuke brush pens are a great option.

Although small brush pens can be easier to learn with, there are some great large brush pen options as well, but they may take a little more practice to learn to control, especially if they have softer nibs. Some of my favorites include the Crayola Broadline; the Tombow Dual brush pens, which have both a brush tip and a fine tip; and Kuretake Fudebiyori, which have good control and are a good medium size to help with the transition. Karin Markers are my personal favorites because I prefer a harder nib and they are so inky that they can also be used for watercolor.

Crayola Broad Line and Crayola Super Tips

After first practicing with a gel ink pen, I used Crayola Broad Line and Crayola Super Tip pens to practice my lettering before moving on to brush pens. While they're not technically brush pens, they work great for brush lettering because the nibs are flexible, so they're a great way to transition into using brush pens.

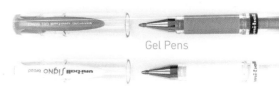

Gel Pens

Gel Pens

There are so many fun, colorful gel pens you can letter with. The ink of gel pens is typically thicker and more opaque than other pens, which makes them stand out when you want to letter on top of other inks. I like to use gold and white Uni-ball gel pens to letter on black paper or to add embellishments to my lettering.

Fine Point Pens

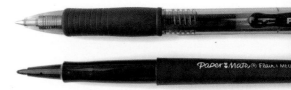

Fine Point Pens

If you haven't purchased your brush pens, you can still practice with any fine point pen, but be sure to test the pen to see how smoothly it writes and to see if it bleeds through the paper (an effect known as *ghosting*). Fine point pens like the Pilot G2 or Zebra Sarasa are a little more inky, so they write smoothly, but the ink can take some time to dry. You can also use felt tip pens like the Paper Mate Flair. Felt tip pens don't have rollerballs that can skip ink, so you'll get a smooth line of ink and they also dry a little faster, which helps avoid smudging.

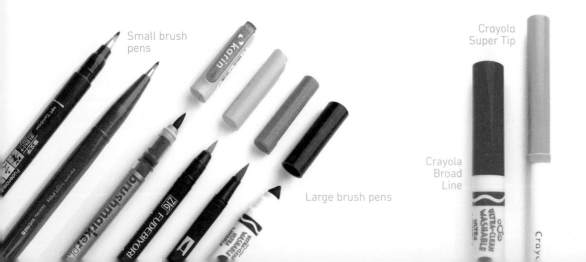

Small brush pens

Large brush pens

Crayola Super Tip

Crayola Broad Line

Other tools and supplies

Here are some other important tools and supplies you'll need for lettering.

Pencils

One of the most useful lettering tools is a basic pencil, which can be mechanical or regular. There are two main types of pencil leads: H and B. H is harder and won't smear as much; B is softer and can be used to create thick downstrokes and thin upstrokes, but it does smear more easily and may not be the best option for sketching large or elaborate pieces. For most projects, I prefer using a pencil with B6 lead, and more specifically, a Blackwing pencil for creating small sketches and a mechanical pencil for creating larger sketches or adding fine point details to projects.

Watercolor Tools

You can create beautiful watercolor lettering using a paint brush and watercolor paints on watercolor paper. There are many types of paint brushes and watercolor paints to choose from, but I like to use a water brush to help control the amount of water on the brush, and I really like using the ink from my brush pens for watercolor. You just need a palette or a smooth surface on which to lay down the ink. (I'll show you some watercolor techniques using brush pens and a water brush later in this book.)

Erasers

Another great tool that gets a lot of use in my lettering is an eraser, which is helpful when I want a pencil sketch to be light, but still visible enough that I can ink over it. There are rubber erasers, plastic erasers, gum erasers, and kneaded erasers. Plastic erasers and gum erasers both work very well. I like plastic erasers because they leave fewer eraser shavings than gum erasers. Kneaded erasers give you a little more control over how much you're erasing, but they don't work as well for erasing larger areas. I don't like rubber erasers because they can tear paper and leave residue. You can use a pencil eraser or pink eraser, but I've noticed some pink rubber erasers can leave a pink residue or tear the paper.

Washi Tape

Use washi tape to create straight lines for lettering pieces or on watercolors to cover areas where you don't want to add the watercolor. There are several different sizes of washi tape. I like to use a regular width to create borders, and a skinny width to create stripes or geometric lines. One thing to watch for when removing washi tape is ripping the paper, so be sure to peel it off slowly. It helps to peel it off at an angle and to the side, instead of straight up.

Washi Tape

Paper

Since brush pens can fray easily, you'll want to use a super smooth paper that won't damage your pens. (If you don't have smooth paper, you can use Crayola markers on any paper.) I've found that HP Premium (32lb) paper, Rhodia notepads, and Bristol smooth paper, marker paper, and tracing paper are all very good options. Tracing paper is nice because it's smooth and you can also use it to trace over the worksheets in this book. Watercolor paper is nice because it adds a textured look, but you may not want to use your brush pens on it because it can fray the pens. Instead, transfer the ink to a palette and then use a brush to apply it.

Pencil

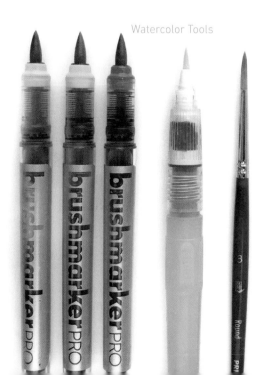

Watercolor Tools

PRISMACOLOR®
Plastic Eraser
Gomme en plastique

Since 1889
GENERAL'S
Gum Eraser
Gomme à Gomme | Gomme a Effacer
#1362 USA | États-Unis | EE.UU

Erasers

GENERAL'S
Kneaded Eraser
Gomme Malléable
Borrador Maleable

Creating Faux Calligraphy

Faux calligraphy isn't about writing in cursive, it's about thickening letters as you draw them to create the look of calligraphy, but doing so without the need for calligraphy pens. This simple technique will help you develop the basic skills you need to move on to brush pen lettering.

How to Create Faux Calligraphy

Faux calligraphy is the best way to begin learning hand lettering because you can use any pen or pencil to create your letters. When I started learning hand lettering, I struggled with a brush pen, but after practicing faux calligraphy, the concept of thickening the downstrokes with a brush pen made more sense to me, and my brush pen lettering improved.

The Three Basic Rules for Creating Faux Calligraphy

Observing these three rules will help you create faux calligraphy that is both elegant and consistent.

RULE **1** **KEEP THE DOWNSTROKE THICKNESS CONSISTENT.**
Keeping your downstroke thickness consistent is the first step for making faux calligraphy appear as if you've used a calligraphy pen to create your letters. If your downstroke thickness varies, your calligraphy can look sloppy and uneven.

RULE **2** **ADD THE DOWNSTROKES ON THE RIGHT SIDES OF THE LETTERS.**
In most instances, I find it works best to thicken the letter on the right side of the basic lettering stroke, but there are a few exceptions where it may be easier to add the downstrokes on the left side of the basic stroke.

RULE **3** **LEAVE ENOUGH ROOM BETWEEN THE LETTERS FOR THE DOWNSTROKES.**
Leaving ample space between the letters will ensure that the downstrokes can be added and the letters won't appear too crowded when the downstrokes are filled in.

LESSON Adding Downstrokes

Adding downstrokes on the right sides of letters

This super simple lesson doesn't require any special tools, all you'll need is a blank sheet of lettering paper and a pen or pencil.

1. Begin by writing any word. Try writing it in a script style and a print style to get a feel for creating faux calligraphy in different styles.

2. Next add a line to the right of each of the downstrokes.

3. Now fill in the downstrokes. That's it!

Adding downstrokes on the left sides of letters

There are some instances where adding downstrokes on the left sides of the downstrokes makes more sense than adding them on the right sides. Here are a few examples.

1. In this instance, I thickened the left side of the first downstroke of the "h" because I didn't want the loop at the top of the letter to be too small. I also didn't want to cut off too much of the curve of the "h", as you can see was the case in the example on the right.

2. If you decide you still prefer to add the downstrokes on the right sides of the letters, you can draw your loops bigger by picking up your pen between strokes and adding the downstrokes before drawing the next stroke to allow for the necessary thickness.

3. In this instance, I decided to add the downstroke to the left of the oval in the "b" because I didn't want to make the oval any bigger. This is another way you thicken the letters based on your personal style. In the end, there is no absolute right or wrong way to add downstrokes to your letters, so experiment to decide which method works best for your lettering style.

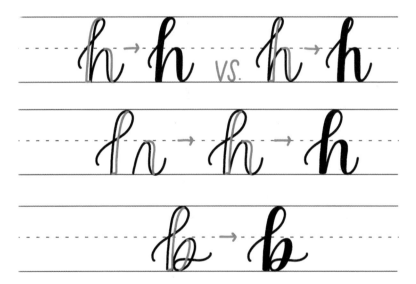

Now that you've learned the basic steps for adding lines to downstrokes, it's time to practice your lowercase letters—this time using the practice worksheets. Practicing with worksheets will help you build muscle memory so you can eventually create your own faux calligraphy alphabet. As you practice, focus on keeping a consistent downstroke thickness and notice where you pick up your pen in between the strokes of the letters. Feel free to practice in the space provided below, use blank lettering worksheets, or trace the worksheets onto tracing paper.

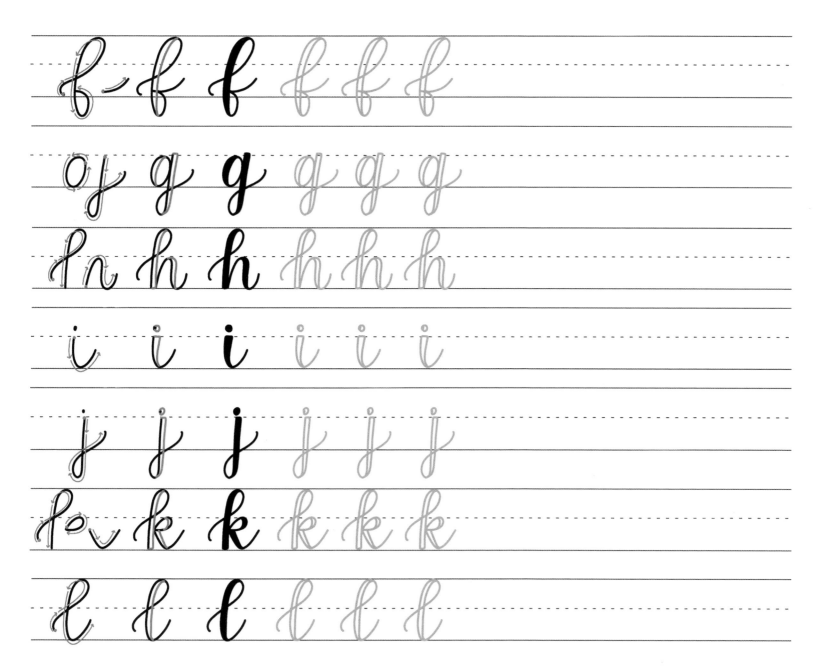

t t t t t t

u u u u u u

v v v v v v

w w w w w w

x x x x x x

y y y y y y

z z z z z z

When I first started lettering, I avoided using uppercase letters because they were a little more complicated to create, but you don't need to avoid using them! The faux calligraphy uppercase alphabet can be a little trickier than the lowercase, so it's important to practice it. And while there are many different uppercase styles, this style is fairly basic so you'll be able to master it with just a little practice.

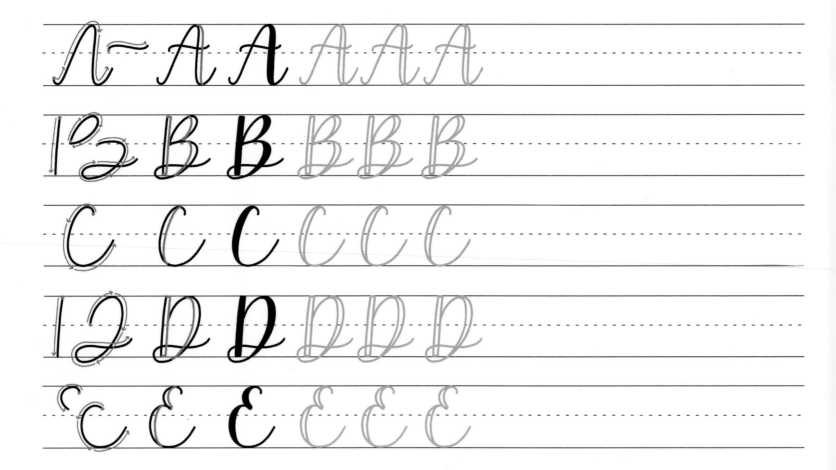

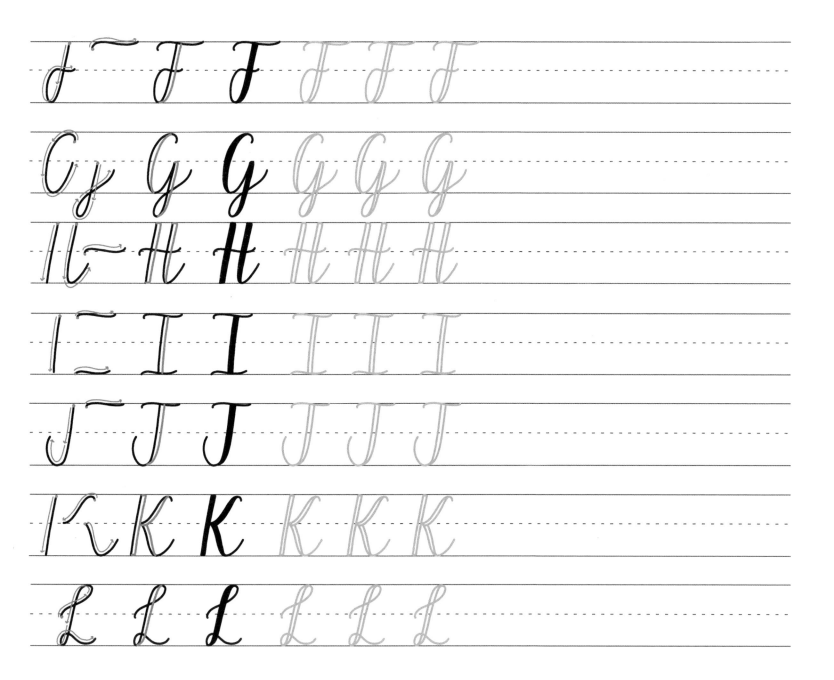

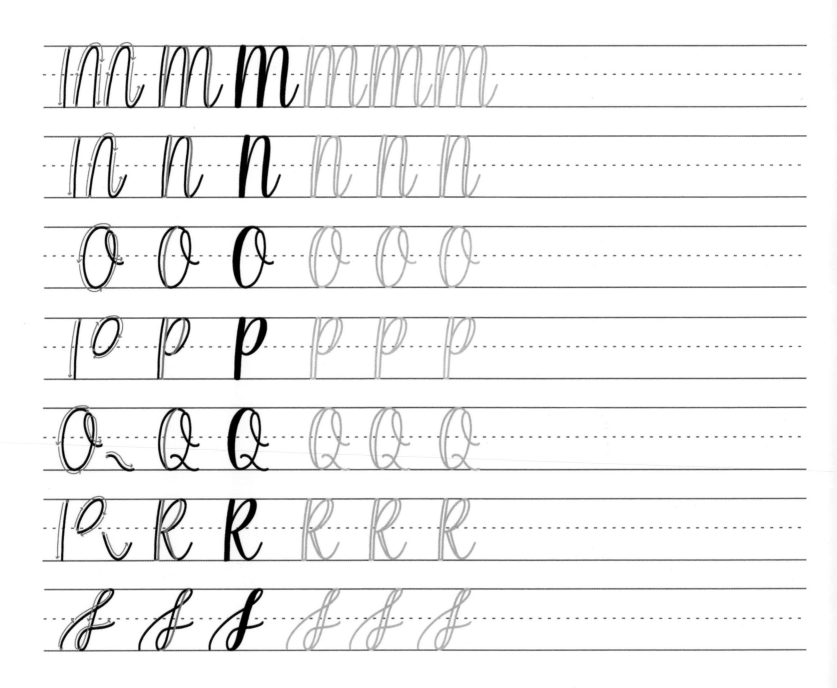

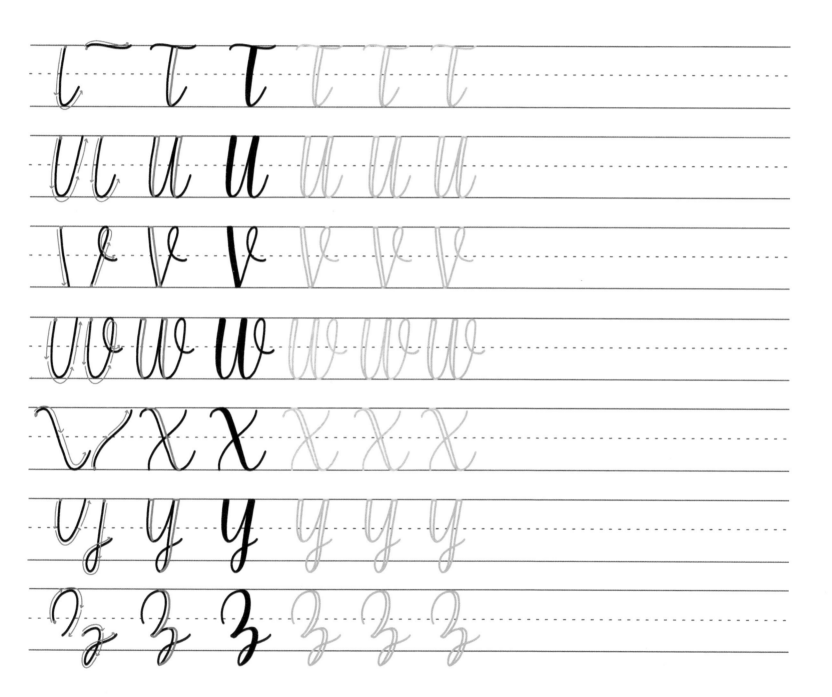

PROJECT Letter Your Name Using Faux Calligraphy

First try lettering my name in faux calligraphy, then letter your own name in the practice space. You'll need a sharp pencil, an eraser, and a black pen. (I like to start with a pencil so there's no pressure to make it perfect the first time.) Feel free to erase as much as you need, and if you prefer not to letter in the book, you can use blank workbook paper instead.

1. Use a pencil to write your name in a script style. Make sure you leave ample space for the downstrokes.

Sarah

2. Use the pencil to add the downstrokes to the letters. Remember that in most instances, you'll be adding the downstroke on the right side of each letter.

Sarah

3. Trace over the pencil marks with the pen.

Sarah

4. Use the pen to fill in the downstrokes and then erase any remaining pencil marks once the ink has dried.

Sarah

GET CREATIVE

Instead of using a black pen to fill in the downstrokes, try using different colored pens to fill in each letter. You can fill the space in completely or even add patterns or doodles in the downstrokes!

Creating Brush Pen Lettering

With faux calligraphy, we manually added the downstrokes to letters, but with brush pen lettering we let the pens do the work. The techniques outlined in this chapter will help you become more comfortable with a brush pen and get you to a point where brush pen lettering feels natural.

How to Create Brush Pen Lettering

Brush pens feature flexible nibs that allow for thicker downstrokes and thinner upstrokes. The key to using a brush pen correctly is learning how to apply the right amount of pressure at the right time.

The 3 Basic Rules of Brush Pen Lettering

Here are a few basic rules that will improve your brush pen lettering results. Once you've learned these basic rules, you'll know how to fix your letters when something looks off. And once you've mastered these basics, you'll be able to bend the rules to create your own style. Using blank lined guide sheets is very helpful for practicing these rules, but you can also use blank tracing paper or dot paper.

RULE 1 MAKE SURE YOUR LETTERS ARE THE SAME SIZE.
Your letters should all be the same width as well as the same height and depth for the ascenders and descenders.

DO THIS… …NOT THIS

RULE 2 CHOOSE AN ANGLE FOR YOUR DOWNSTROKES AND STICK TO IT.
You should be able to draw parallel vertical lines through all of your downstrokes.

DO THIS… …NOT THIS

RULE 3 KEEP THE SPACING BETWEEN EACH LETTER THE SAME.
Being consistent with your strokes will help you achieve consistent spacing between your letters.

DO THIS… …NOT THIS

LESSON How to Use a Brush Pen to Letter

In this lesson, you'll learn the basics of lettering with a brush pen. You'll need a small brush pen and a blank piece of paper.

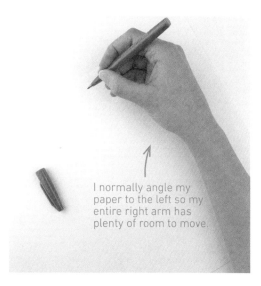

I normally angle my paper to the left so my entire right arm has plenty of room to move.

1. Set up your lettering space.

When you're lettering, your arm is an extension of your hand, which means your arm should be free to move with the pen. I like to place the paper on my desk in a way that allows my whole arm to comfortably rest on my desk with enough room to move. While you're still getting familiar with using brush pens, it might be easier to letter on a hard surface, like a desk. As for the placement of the paper, the angle of the paper isn't critical just as long as you are comfortable and your arm can move with your hand.

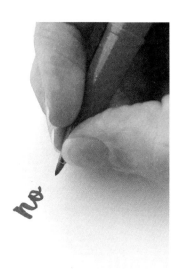

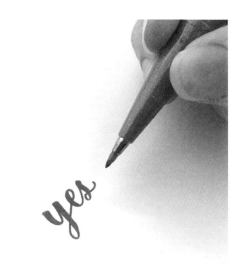

2. Hold the pen the right way.

When holding a brush pen, you'll want to position your fingers on the barrel at least an inch away from the nib (and even farther for large brush pens). This will allow your hand, instead of your fingers, to be in control of the pen. Your entire hand should move with the pen as you letter.

DON'T DO THIS: The pen won't have much range of motion if you are trying to move it with your fingers positioned at the very tip.

DO THIS: Position your fingers at least an inch away from the nib to allow your entire hand, and not just your fingers, to be in control of the pen.

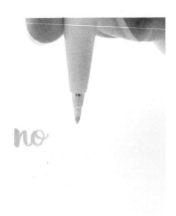

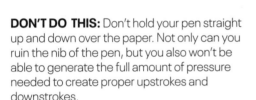

3. Hold the pen at the proper angle.

The angle at which you hold your pen should be at about 45 degrees in relation to the paper surface, and not straight up and down. When you hold the pen correctly, you allow the pen to do the work. Instead of forcing the pen to create the strokes, the pen will work with you to create the right thickness of downstrokes, and you won't feel like you're forcing it as you letter.

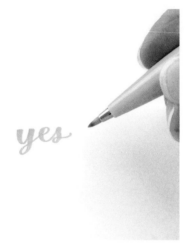

DON'T DO THIS: Don't hold your pen straight up and down over the paper. Not only can you ruin the nib of the pen, but you also won't be able to generate the full amount of pressure needed to create proper upstrokes and downstrokes.

DO THIS: Hold the pen at a 45-degree angle to produce nice letters with thin upstrokes and thick downstrokes.

4. Hold the pen perpendicular to the letters to create consistent downstrokes.

Whether you choose to angle your downstrokes or make them straight up and down, the angle of the pen in relation to the downstrokes should always be perpendicular. Observing this simple rule will make a significant difference in the quality of your letters.

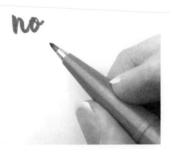

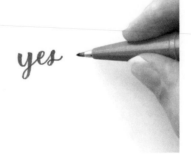

DON'T DO THIS: If the pen isn't perpendicular to the letters when you create the downstrokes, you will create "saggy bottoms" because your pen will be dragging in the wrong places.

DO THIS: Keeping the pen perpendicular to the downstrokes will result in thicker, more consistent downstrokes.

5. Apply lighter pressure for upstrokes and heavier pressure for downstrokes.

The width of the upstrokes and downstrokes is determined by how much pressure you apply to the pen. For other lettering styles, there is no absolute rule about how much pressure you should apply to the pen just as long as you are consistent with your strokes throughout your lettering.

To create a thin upstroke, apply lighter pressure as you guide the pen upward. (Notice how the brush nib is barely touching the paper.)

To create a thick downstroke, apply heavier pressure as you guide the pen downward. (Notice how the nib bends as you apply more pressure.)

6. Apply varying pressure to create smooth transitions.

When you transition from an upstroke to downstroke, or vice versa, you'll adjust the amount of pressure you apply to the pen. You'll want to transition gradually so you can create a smooth curve.

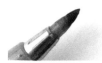
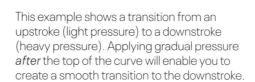

This example shows a transition from a downstroke (heavy pressure) to an upstroke (light pressure). Begin lifting your pen *before* you reach the bottom of the curve to create a smooth transition. If you don't begin lifting your pen until the bottom of the curve, your transition will be too heavy and you'll create a saggy bottom.

This example shows a transition from an upstroke (light pressure) to a downstroke (heavy pressure). Applying gradual pressure *after* the top of the curve will enable you to create a smooth transition to the downstroke.

While these exercises may feel a bit tedious, practicing these strokes will help you get more comfortable with using brush pens before you move on to creating actual letters. You'll need one small brush pen, one large brush pen, and some blank tracing paper if you don't want to practice in the book.

Upstroke

The first basic stroke to practice is the upstroke. Start at the bottom and bring the pen up, using only the very tip of the pen while applying very little pressure.

Small brush pen

Large brush pen

Downstroke

The downstroke is where you'll apply more pressure with your pen. Start at the top and bring the pen down. Practice applying different amounts of pressure and try using different brush pens to explore what your pens can do.

Small brush pen

Large brush pen

Overturn

With the overturn stroke, you'll practice transitioning from lighter to heavier pressure. Start with lighter pressure on the upstroke before applying more pressure just after the top of the curve, and then easing into full pressure as you begin the downstroke.

Small brush pen

Large brush pen

Underturn

The underturn is a transition from heavier to lighter pressure. Start with heavier pressure on the downstroke and then gradually release the pressure right before you get to the bottom of the curve so it's not thick and heavy. (Remember, that's what we call a "saggy bottom.") If you are struggling with this one, make sure you are holding your pen correctly.

Small brush pen

Large brush pen

Compound curve

The compound curve takes some practice because you're transitioning from lighter to heavier pressure and then back to light pressure, all in one stroke and with no breaks. You will get this with enough practice.

Small brush pen

Large brush pen

Ascending loop

The ascending loop is the basic stroke that goes above the midline, like you see with letters such as "l", "h", "k", and "d." Begin with the loop and then curve around to the downstroke. At the top of the curve you will push your pen to the left and start giving it pressure. If you are left-handed, you will pull your pen to the left. This stroke may be easier for lefties because it's easier to pull the pen.

Small brush pen

Large brush pen

Descending loop

The descending loop goes below the baseline for letters like "g", "y", and "j." Make sure you begin lifting your pen just before the bottom of the curve so you don't create a saggy bottom. You will be pushing your pen to the left, so lefties may find this one a little easier than righties.

Small brush pen

Large brush pen

Oval

The oval is the basic stroke that most people struggle with, although lefties tend to have an easier time with it because the pen goes to the left. You should begin on the right side of the oval because a thin upstroke to finish the oval is easier to connect than a thick downstroke. Transition gradually from lighter to heavier pressure, and then back to lighter pressure. Again, watch for that saggy bottom.

Small brush pen

Large brush pen

TIPS FOR BRUSH PEN LETTERING SUCCESS

- Go slow! There's no need to rush your lettering. These rules may feel a bit overwhelming at first, but slowing down will help you relax and notice the details in your lettering. Picking up your pen in between each stroke will help you pause as you prepare to create the next stroke, and it also gives you a break between each stroke.

- Use your whole arm to letter, not just your fingers. You'll have more control of your upstrokes when you engage your entire arm.

- Practice intentionally. Notice how the pen feels in your hand and how it gives to different amounts of pressure. You'll build muscle memory by repeating the process over and over.

- It may sound strange, but stay hydrated and don't forget to eat. I notice my hands are a little shakier when I haven't eaten in a while or haven't had enough water to drink.

- If you continue to struggle, try using a different brush pen. You may find you are more comfortable with using a large brush pen over a small brush pen, or vice versa. Everyone is different, so find what works best for you. Also, brush pens will fray after some use, so if you're struggling with your upstrokes and have tried everything else, try a new pen.

- As you practice, get into the habit of trying to end your exit strokes in the same spots. Developing this consistency will help when you start connecting letters.

WHAT IF YOU'RE LEFT-HANDED?

If you're a lefty, the techniques in the lesson still apply to you, but with one distinct difference: Instead of pulling the pen as you letter, you will be pushing it. You may even find there are a few strokes that are easier for you to perform than they are for righties.

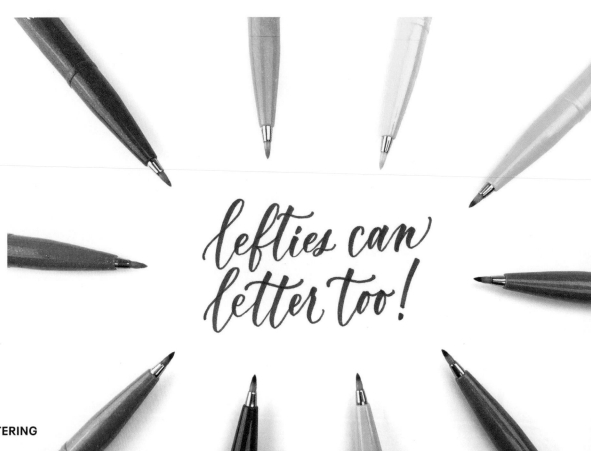

Learn the RULES like a pro, so you can BREAK them like an artist.

-PICASSO-

When you're writing in cursive, you don't pick up the pen until the end of a word. With brush lettering, however, you do pick up the pen after each stroke. These practice worksheets will show you where to pick up your pen between strokes. For these worksheets, you'll need a small brush pen and some blank tracing or workbook paper, in case you don't want to letter directly in the book.

f f f f f f

g g g g g g

h h h h h h

i i i i i i

j j j j j j

k k k k k k

l l l l l l

m m m m m m

n n n n n n

o o o o o o

p p p p p p

q q q q q q

r r r r r r

s s s s s s

t t t t t t

u u u u u u

v v v v v v

w w w w w w

x x x x x x

y y y y y y

z z z z z z

The small brush pen uppercase alphabet doesn't use the same strokes as the lowercase alphabet, but you'll still pick up your pen as you create each letter. For these worksheets, you'll need a small brush pen and some blank tracing paper or workbook paper.

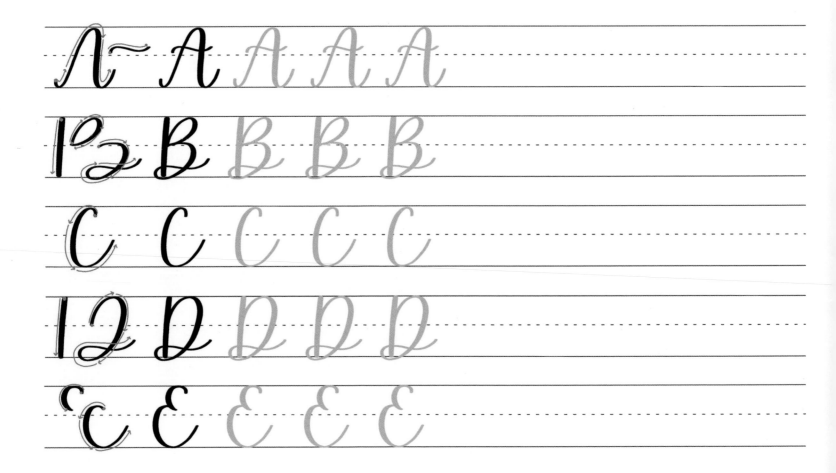

F F F F F F

G G G G G G

H H H H H H

I I I I I I

J J J J J J

K K K K K K

L L L L L L

Mm Mm Mm

Nn Nn Nn

Oo Oo Oo

Pp Pp Pp

Qq Qq Qq

Pr Rr Rr

Ss Ss Ss

While the letters on these worksheets are not separated into strokes, you should still continue to focus on picking up your pen between strokes. For these worksheets, you'll need a large brush pen and some blank tracing paper or workbook paper.

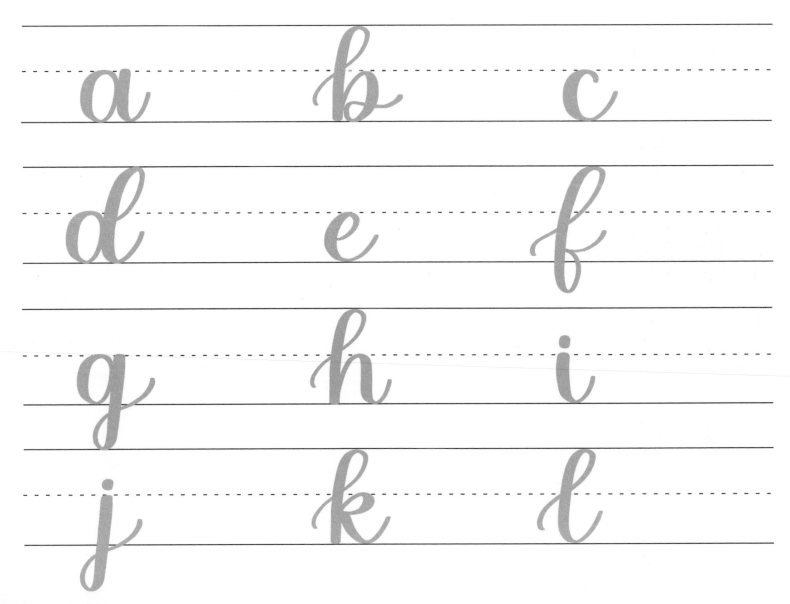

m n o

p q r

s t u

v w x

y z

A B C

D E F

G H I

J K L

m n o

p Q R

S T U

V W X

Y Z

PROJECT Letter a Word Using a Small Brush Pen

Now that you've practiced lettering the alphabet, let's try breaking down the strokes in a word and then lettering the word using different colored brush pens. In this exercise, you'll use a different color for each stroke to emphasize picking up your pen in the right places. You'll need six small brush pens in different colors and some lined practice paper, in case you don't want to letter in the book.

1. Letter the individual strokes of "alphabet" using a different color for each stroke. Be sure to keep the strokes separated so you can see them clearly.

2. Next, letter "alphabet" by connecting the different-colored strokes.

3. Now letter "alphabet" again, but this time use the same color for each letter. Make sure you're still picking up your pens between each stroke!

GET CREATIVE

You can love your lettering right now—even without a lot of experience! One way to do this is by adding colors and embellishments to your letters that make them feel unique to you. (These are *your* letters after all!) Here are some creative ideas to try as you become more comfortable with your brush pens.

alphabet

Add some embellishments to the downstrokes with a white gel pen. Just make sure your word is dry first so the white ink doesn't blend into the colors.

Use a black fine point pen to add shadows, and a white gel pen to add highlights.

alphabet

alphabet

Letter your word with a black brush pen and when it's dry, use different colored pens to add colorful shadows.

Thicken the downstrokes so there is room to add stripes with a gel pen.

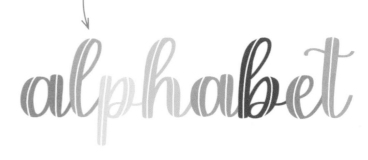

Making Lettering Connections

In this chapter, you'll learn the basic rules for making lettering connections, along with some common exceptions. There are many different combinations of connections, but the techniques in this chapter will help you know a tricky connection.

How to Connect Brush Pen Letters

This is where you get to start connecting your letters to make words! Once you start feeling more comfortable with a brush pen and begin lettering more words, you may begin to notice that some letters are really tricky to connect. By observing and practicing the simple rules and concepts outlined in this chapter, you'll begin to master some of those tricky lettering connections.

The 3 Basic Rules for Connecting Letters

Here are a few basic rules that will help make your connections so much easier. Remember, these rules can all be broken when you start creating letters in your own style, but mastering these rules as you learn hand lettering will enable you to break them intentionally, while still maintaining a consistent look. After mastering these rules, you'll be able to letter any word in your own unique way.

RULE

1 **KEEP THE SPACING CONSISTENT.**

Keeping the spacing of your connections consistent is important. Each letter should be the same distance apart throughout the word. Since you've already practiced picking up your pen between strokes, you're familiar with how each letter starts and ends. Keep in mind, though, that even though letters will be touching when you make the connections, you'll want to make sure each letter has room to "breathe." If your letters are squished together and don't have an obvious ending, they may end up blurring together and making your words difficult to read. Try practicing the correct example in the space provided.

DO THIS... ...NOT THIS

KEEP THE CURVES CONNECTING EACH LETTER THE SAME WIDTH.
You can use a round or sharp curve just as long as you're consistent throughout the word. Try practicing the correct example in the space provided.

DO THIS... ...NOT THIS

hand *hand.*

KEEP THE CONNECTION POINTS LEVEL.
You should be able to draw a level, straight line through the connection points between every letter in a word and where one letter meets the next. It doesn't matter exactly where the connection point is just so long as the connection points are consistent. This rule applies for almost all letters, although there are a few exceptions: R, S, X, Z don't have connection points to start because they continue from the previous letter. Try practicing the correct example in the space provided.

DO THIS... ...NOT THIS

hand *hand*

The Four Common Connection Classifications

Understanding these basic types of connections will make your words look more consistent. It may feel a little overwhelming to think about how many possible letter connections there are, but grouping letter connections into these four basic classifications will help. These classifications are based on how the certain types of letters end and how the connections are formed with the letters that follow.

1 LETTERS WITH SIMPLE CURVES.
The first type of connection classification is the most basic, using a **simple curve.** This type of connection is common for letters that don't have descenders.

These are examples of letters that are connected using a simple curve.

a c d e h i k l m n r t u x

Practice making this type of connection by connecting a few letters using a simple curve.

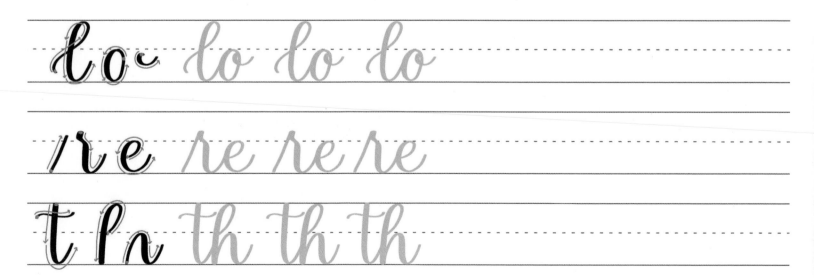

2 LETTERS WITH DESCENDING LOOPS.

The next type of connection is made using a **descending loop**. The 3 basic rules still apply to this group, except you don't have the curve to connect the letters. Instead, you'll be using an upward angle to connect the letters. it's important to keep a similar angle for each letter in any word that uses this type of connection.

These are examples of letters that are connected using a descending loop.

$$f \quad g \quad j \quad q \quad y \quad z$$

Practice making this type of connection by connecting a few letters using a descending loop.

fe fe fe fe

qu qu qu qu

yo yo yo yo

za za za za

3 **LETTERS WITH CURVES THAT DON'T TOUCH THE BASELINE.**
The third group is comprised of letters that have curves that don't touch the baseline. The 3 basic rules still apply, although the curve will not touch the baseline.

These are examples of letters that connect using a curve that doesn't touch the baseline.

b p s

Practice making this type of connection by connecting a few letters using this kind of curve.

4 LETTERS THAT HAVE SMALL TAILS AT THE ENDS.

The fourth group of connections are made from letters that have small tails that end the letters, which adds a distinct end to the letter before the next letter starts. Remember: you want each letter to have room to breathe, so keep that in mind as you practice the connection with this type of letter.

These are examples of letters that feature this unique tail to end the letter.

o v w

Practice making connections by connecting a few letters using this kind of unique feature.

ou ou ou ou

ve ve ve ve

wh wh wh wh

on on on on

The Four Common Connection Point Exceptions

While most letters can be connected using the preceding rules, there are instances where brush script letters have different connection points that don't fall neatly into those four classifications. Instead, the connections start from the stroke of the previous letter, but are made without lifting the pen. This means they don't have the same connection points and can be tricky to create unless you're aware of when these instances occur. I've used different colors to show you how some of these connections are unique.

1 CONNECTING USING A SIMPLE CURVE.

The first type of connection classification is the most basic, using a **simple curve.** The type of connection is common for letters that don't have a descender. These are examples of letters that are connected using a simple curve. Try using different colored pens to understand how these unique connections work.

2 CONNECTING LETTERS TO A LOWERCASE "R".

The most common tricky connection is connecting any letter connecting to a lowercase "r." This is a very common connection, so you'll see it a lot and it's important to understand. One reason it's tricky is because the "r" doesn't have the same connection point as most other letters. To fix this, you need to extend the previous letter to start the "r," and this can vary based on the previous letter. Practice the following connections to get a feel for connecting to an "r" using different letters.

br br br br

dr dr dr dr

er er er er

fr fr fr fr

gr gr gr gr

or or or or

3 CONNECTING DOUBLE LETTERS.

Another common tricky connection scenario is connecting double letters. With double letters, the goal is to make sure both letters are as similar as possible and are connected at an even connection point. Of course, they may not be exactly the same since we aren't computers and are doing this by hand, but with practice you'll get better at making your double letters similar. Practice making connections with the following common double letters scenarios.

4 CONNECTING UPPERCASE LETTERS.

Quite often it can be confusing when you're trying to decide how and when to connect uppercase letters to lowercase letters. Some uppercase letters simply can't be connected to lowercase letters, while others can only be connected with certain lettering styles, so don't worry about always trying to connect them if you can't find a solution. Practice this simple uppercase series to see how some uppercase letters are connected to the lowercase letters that follow.

Be Be Be Be

En En En En

Fa Fa Fa Fa

Lo Lo Lo Lo

Op Op Op Op

Th Th Th Th

PROJECT Connecting Letters to Build Words

In this project, you'll practice making connections by lettering a sentence using a different color for each stroke. Focus on the spacing, curves, and connection points. You'll need six different-colored brush pens and blank workbook paper in case you don't want to letter in the spaces below.

They

write

pretty

words

They write pretty words.

GET CREATIVE

Now that you know the basics of connecting letters, you can get creative and change things up to make your letters more unique to you. Notice how changing small details can change the overall look and feel of your letters. Remember, there isn't a right or wrong way to do this, just as long as you're consistent. If you're struggling with making certain connections, don't be afraid to change the style of individual letters to find something that is easier to execute. Just remember that each letter needs to have a beginning and an end, and it should have room to breathe.

calligraphy

Regular connections used

calligraphy

Connection points are moved up higher

calligraphy

Connection points are consistent, but spread out

calligraphy

Sharper angles used instead of smooth, round curves

Laying Out Quotes

This is where lettering really gets fun because you can start making beautiful pieces that are unique to you! I've shown you the rules of lettering, but there aren't really any hard rules when it comes to laying out quotes, because every quote is unique.

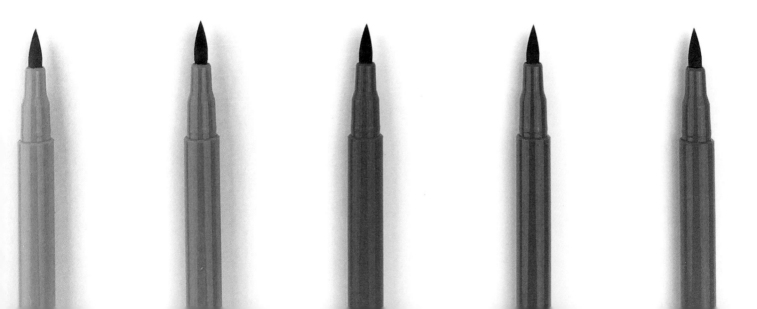

How to Lay Out a Quote

Now that you know how to connect letters, it's time to put together a quote! In this lesson, I'll show you the process behind planning and laying out a quote, and also give you some ideas you can use to create your own quotes. This is the time to brainstorm all of your ideas, so don't be afraid to try different configurations. If you don't get your final lettering piece right on your first try, that's okay! Following these steps will help you finalize your idea before you ever put a pen to paper, and also help you come up with a design that inspires you.

1. Choose a quote that inspires you.
Start with a shorter quote—about four to five words is usually enough. Write out your quote on a piece of paper and circle which words you feel are most important to emphasize, or which words you want to keep together.

2. Choose a size and shape.
Ask yourself what you'll be using the piece for. Will it be square or rectangular? Is there a certain size of frame you will be using for the finished piece? Asking these questions will help you decide if you need to use small or large brush pens.

3. Sketch out thumbnails.
Using a pencil or brush pen, sketch out thumbnails of your quote. They don't need to be perfect, but they should give you several ideas of how you want your finished piece to look.

4. Experiment with the alignment. Try left, center, and right alignments to see which configuration you like best.

5. Experiment with the focal point. What words do you want to stand out? Choose what you want to emphasize in your quote. You can make them stand out by changing the color, size, or font style.

6. Experiment with the baseline. Try changing the baseline of your letters to be diagonal, wavy, or curved. This is an easy way to add some interest while still keeping your lettering simple.

Before you create your own full-sized quote, practice laying out quotes by tracing these ideas. Don't be afraid to experiment and use different pen colors and techniques! You'll need a small brush pen and some tracing paper.

When
nothing
goes
right
GO LETTER.

Love
Laugh
Letter

letter more, worry less.

so many letters so little time.

Life is what you letter it.

Dream BIG. Letter BIGGER.

PROJECT Create a Full-Sized Version of Your Own Quote

Sketch an idea you love in pencil and then go over it with brush pens.
Add color, doodles, or even a background—adding things you like will
make the piece more unique to you. Don't be afraid to make it yours!

Breaking the Rules

Now that you've practiced the basic rules of lettering, it's time to start breaking those rules to create your own look! In this chapter, you'll learn how to create bounce lettering and how to use simple techniques to create your own unique letters. This is the best part of hand lettering because you get to express yourself through your own creative lettering!

Create Bounce Lettering

Bounce lettering is a fun way to start experimenting with the style and look of your own letters. In this section, I'll show you some guidelines for "bouncing" your letters, but you can play with these guidelines as you create your own bouncy style. There isn't any one right way to create bounce lettering—you get to decide what you love or don't love as you create your own unique look. This is where you get to make your letters dance!

1. VARY THE BASELINE OF THE LETTERS.
So your letters will still look consistent, start by drawing a line below the baseline where each bouncing letter will touch. How do you know which letters to bounce? You get to choose! To keep it simple, start by trying to bounce every other letter in a word. Vowels tend to look better if they are small, so I don't usually give any bounce to them.

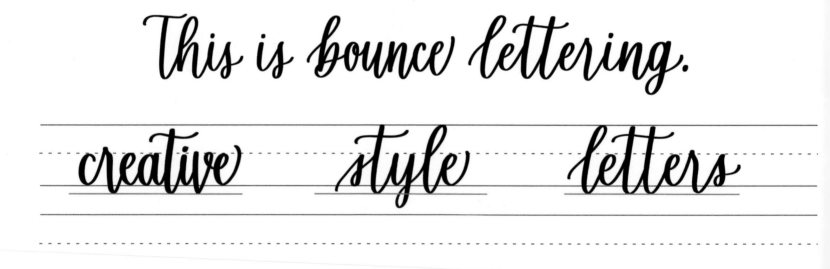

2. VARY THE SIZING OF THE LETTERS.

For bounce lettering, the size of your letters doesn't need to be totally consistent. You can still create a somewhat consistent look by adding additional lines where your smaller letters will touch.

This is bounce lettering.

creative *style* *letters*

3. CHANGE THE SPACING BETWEEN THE LETTERS.

While the letter spacing should still be consistent throughout each word, changing the spacing between letters can help create different lettering styles. Closer spacing may feel like a quirkier bounce, while a wider spacing may feel like a more elegant bounce.

This is bounce lettering.

creative *style*

PROJECT Letter Your Name in Bounce Lettering

Try lettering your name in a bouncy style. Begin by practicing my name, then practice your own name by starting with a pencil and then going over it with a brush pen. When you finish, compare your name from the beginning and see how your lettering has changed.

1. Change the baseline.

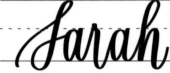

2. Change the size.

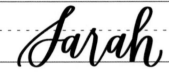

3. Change the spacing.

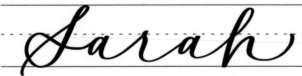

4. Mix different techniques.

GET CREATIVE

You can be creative with these techniques to come up with unique styles. Each style conveys a different feeling and can be used for different purposes. The look of a wedding invitation might be elegant and classy, while an invitation to a child's birthday party might look fun and playful.

be kind

This style might be used if you want an elegant, classy, or formal look.

be kind

The feel of this style is quick, straight, or modern.

be kind

This style works for a cute, round, loopy look.

be kind

This style looks cozy, narrow, and young.

be kind

You might see this style for something chunky, sharp, or expressive.

be kind

You may use this style for something fun, playful, and casual.

be kind

The look of this style is quirky, festive, and unique.

be kind

This style feels calm, elongated, and smooth.

Create Your Own Letters

The following techniques will help you start creating a style that you love and is unique to you. As you practice and explore new styles, you'll continue to improve and also notice what you like and don't like about the letters you create. Remember, hand lettering is a way to express yourself. If you start to feel like you can't come up with anything unique, don't get discouraged. The way you letter now is exactly where you should be, so just enjoy where you are right now! As long as your letters are legible, the possibilities are endless.

1. CHANGE THE MIDLINE.
Moving the midline up or down creates a different look.

letter regular *letter* high *letter* low

h regular *h* high *h* low *s* regular *s* high *s* low *c* regular *c* high *c* low

regular high low regular high low regular high low

2. ADJUST THE SIZE.

Try changing the height or width of your letters to make them look tall or stretched.

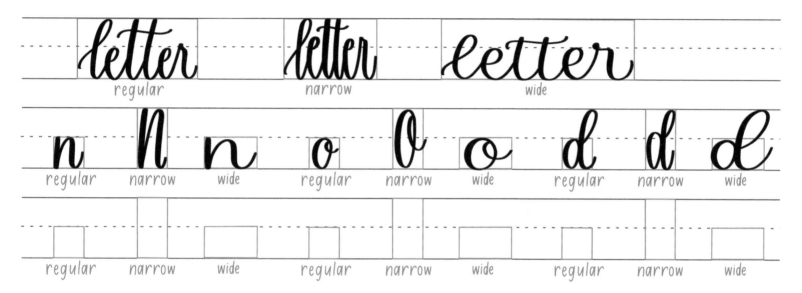

letter — regular letter — narrow letter — wide

n — regular n — narrow n — wide o — regular o — narrow o — wide d — regular d — narrow d — wide

regular narrow wide regular narrow wide regular narrow wide

3. EXPERIMENT WITH THE SHAPE.

Get creative with the shape of your letters by making them curvy or straight.

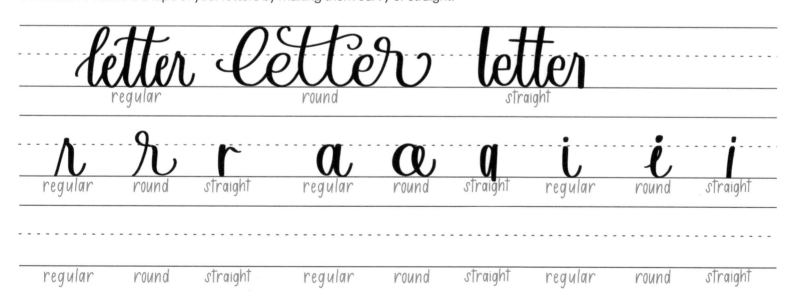

letter — regular letter — round letter — straight

n — regular n — round r — straight a — regular a — round a — straight i — regular i — round i — straight

regular round straight regular round straight regular round straight

regular round straight regular round straight regular round straight

4. VARY THE DOWNSTROKES.

Change the thickness of the downstrokes to make your letters look simple or chunky.

letter *letter* *letter*

thin regular thick

b *b* *b* *w* *w* *w* *m* *m* *m*

thin regular thick thin regular thick thin regular thick

thin regular thick thin regular thick thin regular thick

5. EMPHASIZE THE ENTRANCE AND EXIT STROKES.

Experiment with different entrance and exit strokes to add interest and fill up space.

letter *letter* *letter*

e *e* *e* *g* *g* *g* *k* *k* *k*

Try coming up with different styles for each letter to create an alphabet collage like I've done here. Choose one letter and then come up with as many styles as you can think of. You can do this over and over again with individual letters and literally fill up pages with your own creative styles. You may even use these new styles as reference for new lettering projects!

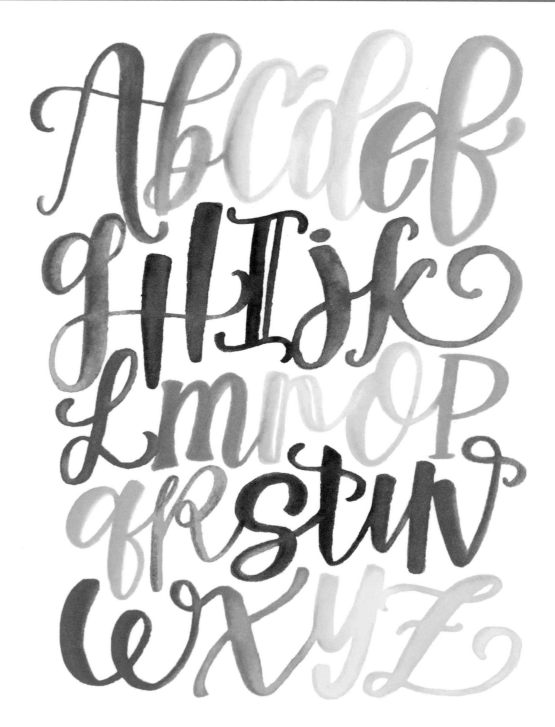

Creating Basic Font Styles

We've covered the basics of hand lettering, now comes font practice and projects! This chapter will get you started with a few of my favorite font styles, while showing you some fun ways to use your new lettering skills. Have fun with this and try coming up with your own unique alphabets!

BE
brave
AND
kind

Monoline Script

Monoline means a single line, which in lettering means there is no contrast between the thick and thin strokes. Instead, the strokes are all the same width, so they can be created using any type of pen. This is a calm font style and can be used in place of cursive, and since it's not too busy it works well for longer quotes. It's also very simple so it can be paired with bolder fonts. It can be created with a paint pen on wood or glass, or you can use it for chalk lettering, which is what we'll be doing in the project.

Aa Bb Cc Dd Ee Ff
Dg Hh Ii Jj Kk
Ll Mm Nn Oo Pp
Qq Rr Ss Tt Uu
Vv Ww Xx Yy Zz

Practice the monoline script font by tracing the letters or practicing in these worksheets. You can use any fine point pen, but try experimenting with both fine tips and large tips to see which size you like best.

Aa Aa Aa

Bb Bb Bb

Cc Cc Cc

Dd Dd Dd

Ee Ee Ee

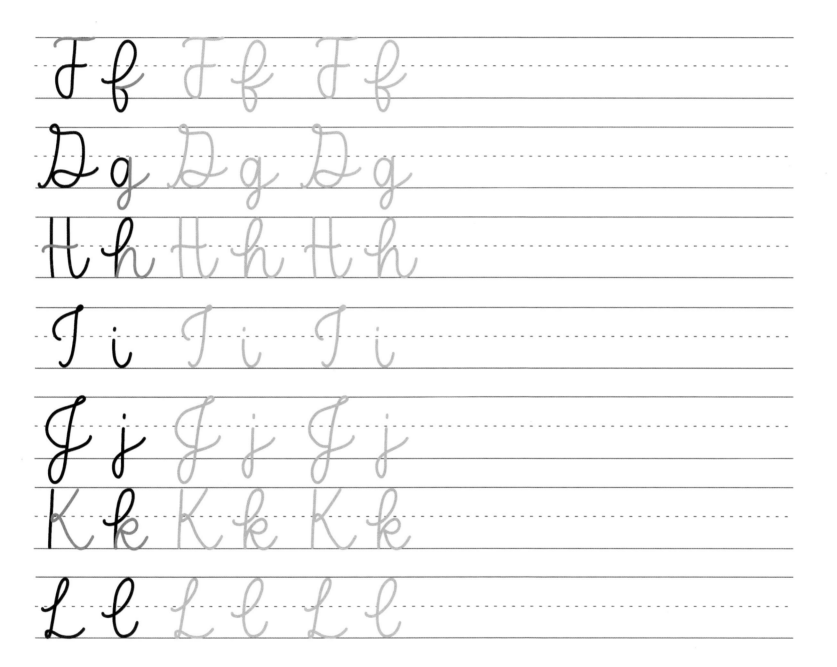

Mm Mm Mm

Nn Nn Nn

Oo Oo Oo

Pp Pp Pp

Qq Qq Qq

Rr Rr Rr

Ss Ss Ss

Tt Tt Tt Tt

Uu Uu Uu Uu

Vv Vv Vv Vv

Ww Ww Ww Ww

Xx Xx Xx Xx

Yy Yy Yy Yy

Zz Zz Zz Zz

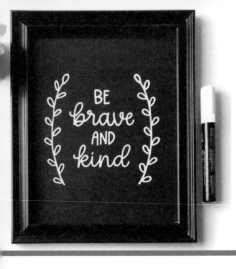

PROJECT Framed Chalkboard Quote

There are so many beautiful things you can do with chalk lettering! You can chalk letter on wood using a paint pen or letter directly onto a chalkboard with regular chalk. I like to letter directly onto glass—it's easy to erase with a paper towel if you make a mistake or you want to change the quote. (Note that you may need to dampen the paper towel if it's been dry for a few days.)

YOU'LL NEED

Pencil

Chalk marker

Paper towel

Scratch paper

Black paper (or any other darker colored paper of your choice)

Picture frame with a glass insert

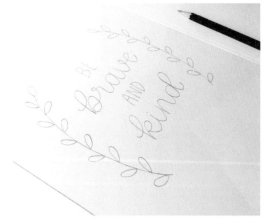

1. Sketch the quote on scratch paper.
Because this is a simple script, you may want to add some embellishments. I've added leafy vines, but you could also add a wreath or banner.

2. Letter the quote on the glass.
Insert the paper behind the glass insert. Make sure the glass in the frame is clean and dry. Prep the chalk marker by pumping it on scratch paper a few times, then begin lettering the quote onto the glass. (If you're right-handed, it's best to do everything in the design on the left side of the frame first. If you're left-handed, it's best to do anything in the design (besides the lettering) on the right side first.) Be extra careful as you letter because chalk markers do take some time to dry.

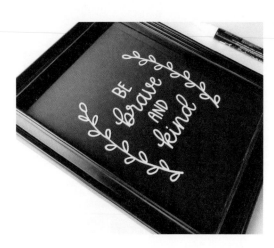

3. Frame the quote.
Insert the black paper behind the quote and place the glass in the frame.

GET CREATIVE

If you have different colored chalk markers, you can blend directly on the glass or add some color to your letters! Bright colors stand out nicely against a black background. You can also experiment using negative space by leaving some of your letters open instead of filling them in.

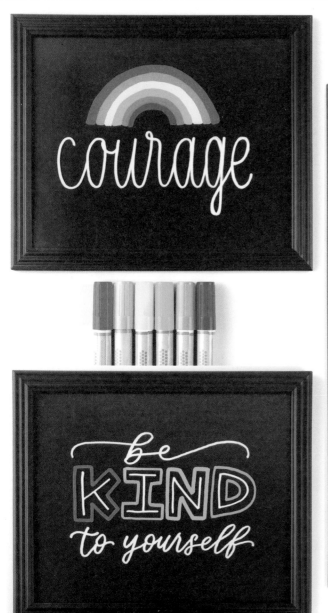

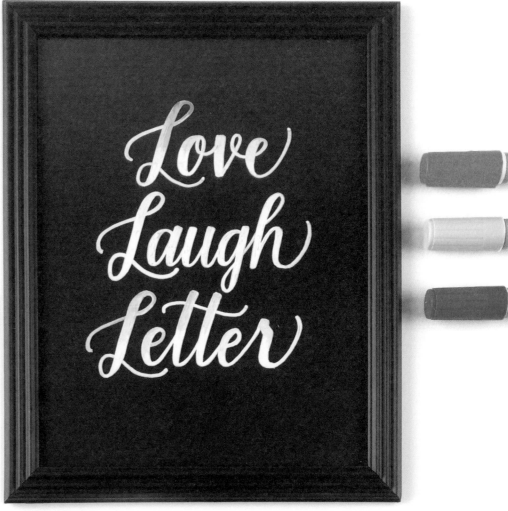

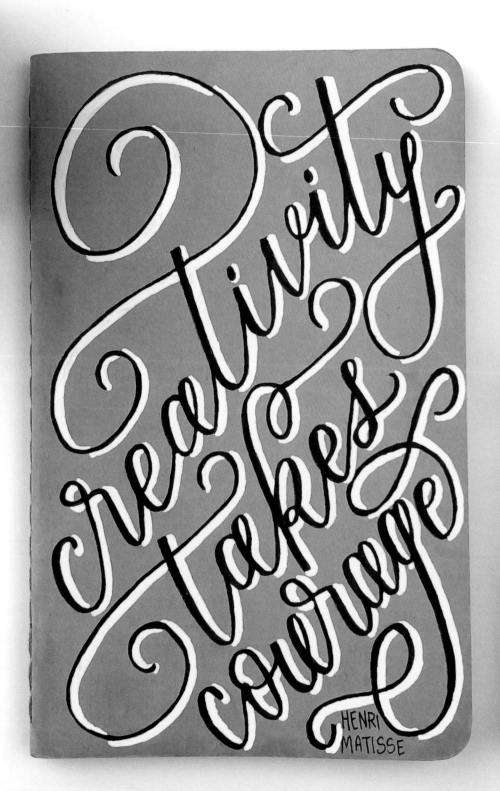

Creativity takes courage

HENRI MATISSE

Flourished Script

This font style has a lot of flourishes and loops, which give it a cute and cozy feel. The flourishes you add to each letter may be different, depending on how your letters fit together in a quote, and since it's elaborate and has a lot more detail than some other fonts, be intentional with your flourishes so your quote is legible. This font can be created using large or small brush pens.

Aa Bb Cc Dd Ee Ff

Gg Hh Ii Jj Kk

Ll Mm Nn Oo Pp

Qq Rr Ss Tt Uu

Vv Ww Xx Yy Zz

Practice the flourished script font by tracing or practicing in these practice worksheets. You'll be practicing a lot of loops, and the loops and flourishes of each letter might change depending on the layout of your quote and how each letter works together.

Aa Aa Aa

Bb Bb Bb

Cc Cc Cc

Dd Dd Dd

Ee Ee Ee

F f F f F f

G g G g G g

H h H h H h

I i I i I i

J j J j J j

K k K k K k

L l L l L l

Mm Mm Mm

Nn Nn Nn

Oo Oo Oo

Pp Pp Pp

Qq Qq Qq

Rr Rr Rr

Ss Ss Ss

Tt Tt Tt

Uu Uu Uu

Vv Vv Vv

Ww Ww Ww

Xx Xx Xx

Yy Yy Yy

Zz Zz Zz

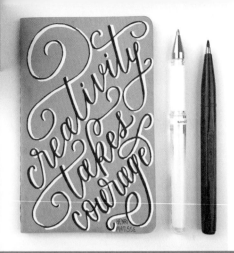

PROJECT Notebook Cover with Shadows

Adding shadows is a great way to make your flourished script lettering pop. There are so many different things you can do with shadows—you can add dimension to your letters or you can add really thick shadows to make your letters look three dimensional. With this font style, you can get creative with where you add flourishes and with how loopy you make the letters. Don't be afraid to experiment! Think about the letters and flourishes as pieces of a puzzle that fit together.

YOU'LL NEED

Pencil

Eraser

Scratch paper

Black brush pen

White gel pen or paint pen

Notebook with blank cover

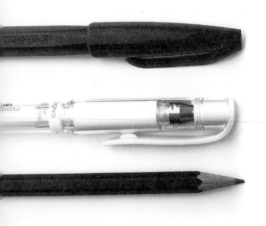

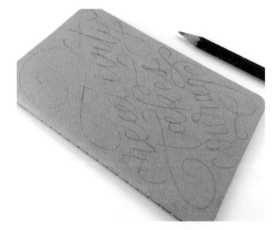

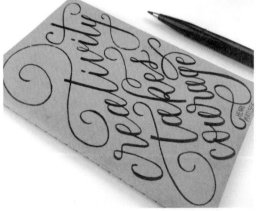

1. Sketch the quote on scratch paper.
Use a pencil to lightly sketch or trace your lettering onto the notebook cover.

2. Go over it with the black brush pen.
Once you've traced the letters onto the notebook cover, go over them with the black brush pen.

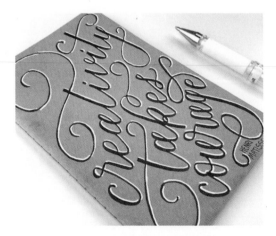

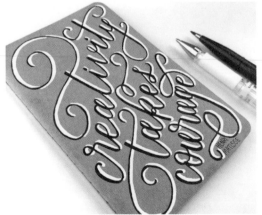

3. Add shadows with the white gel pen.
As you add your shadows, remember that if light was shining at your words from one direction, it would cast a shadow to the opposite side, so only place the shadows on one side of the letters. (I like to add shadows to the right and underneath the letters, but you can choose any side.)

4. Add thicker shadows.
If desired, you can add even thicker shadows to make them stand out more. If the white gel pen has covered up some of the black lettering, go back and touch up the letters with the black brush pen to create crisp lines.

GET CREATIVE

When I letter with colors like yellow that are harder to see, I like to add black or gray shadows behind the letters to ensure they're still easy to read. You can also add a black shadow to bring together colorful lettering or you can create a color shadow with black lettering. Try lettering in a lighter color on a dark background and then adding colorful shadows using different colored pens.

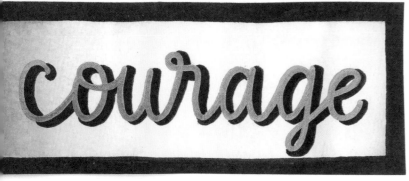

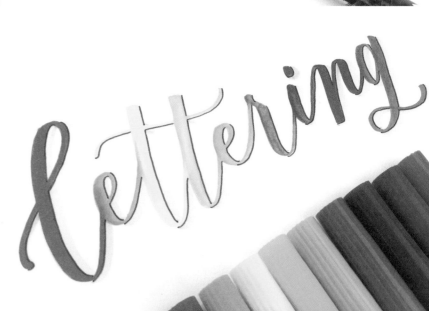

NEVER LOSE YOUR SENSE OF *wonder*

Chunky Faux Calligraphy

This font style is fun and bold! It stands out because it's so thick and it works great when used to emphasize a specific word in a lettering piece. And because it's faux calligraphy, you can use any fine point pen to create it. That means you can create this font with a paint pen on wood or glass, or you can use chalk. And because the downstrokes are so chunky, you can leave them open for a unique look or fill in the downstrokes with color.

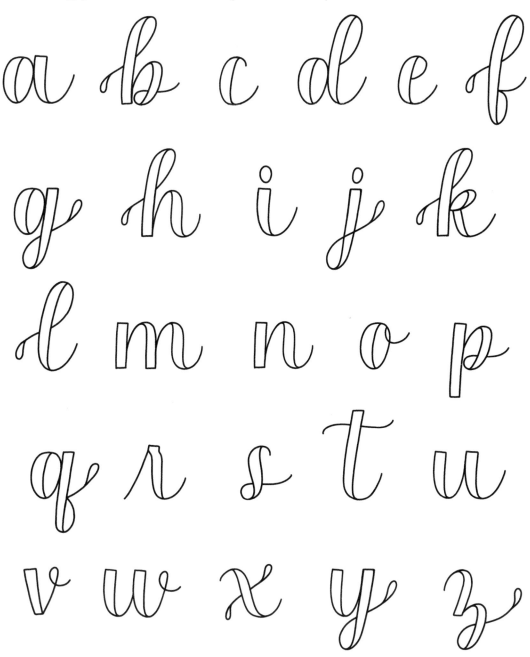

Practice chunky faux calligraphy by tracing or practicing in these worksheets. You can use any fine point pen for these worksheets.

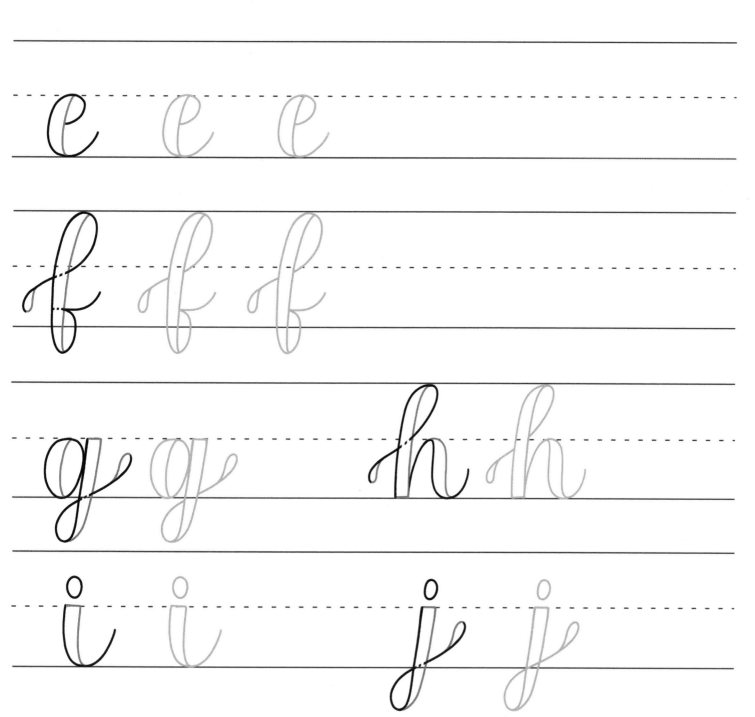

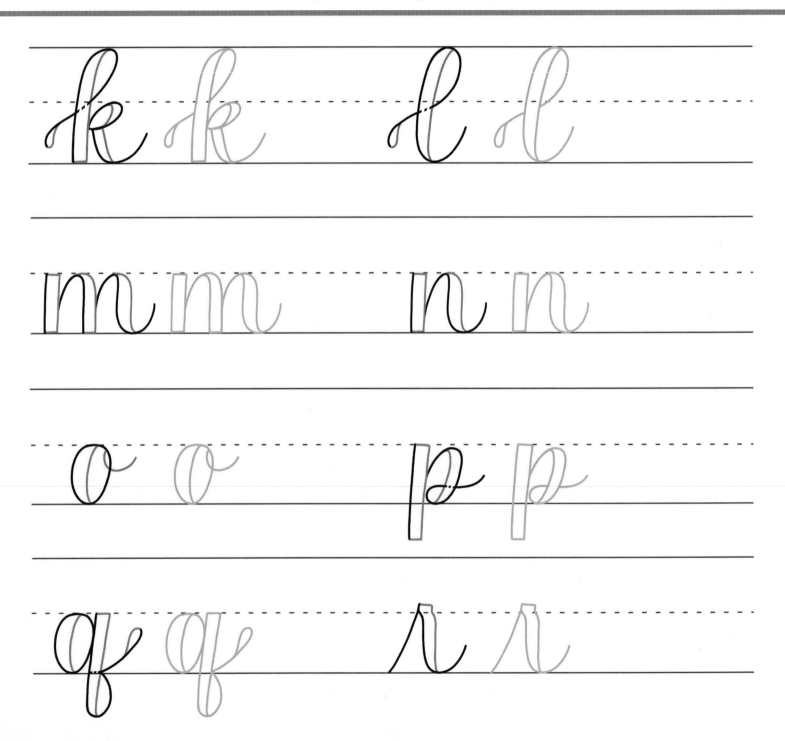

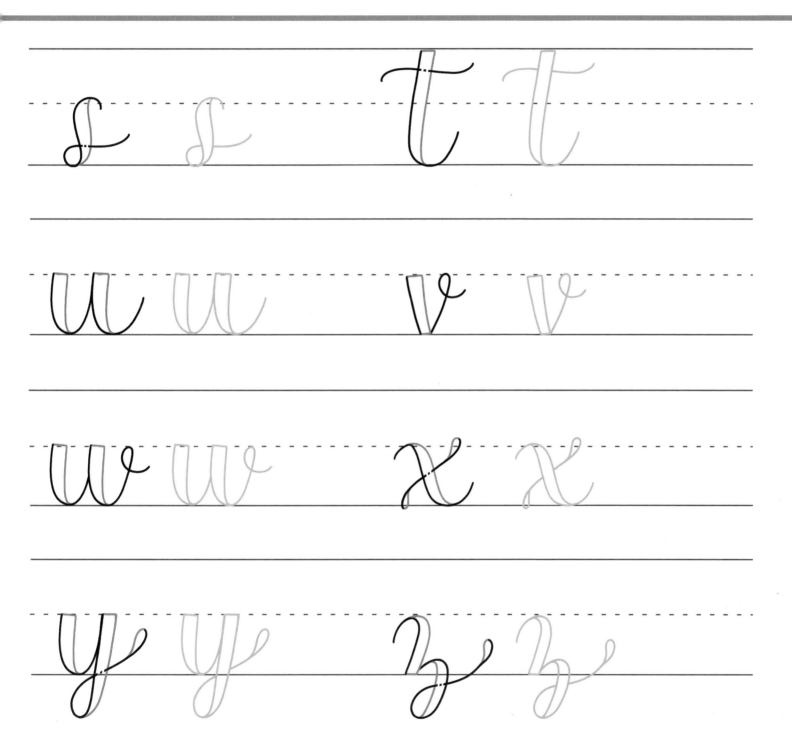

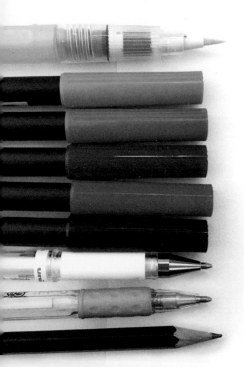

PROJECT Frameable Wall Print Using Galaxy Lettering

Galaxy lettering is a beautiful technique for adding visual interest to your letters. This technique will work with any water-based pen, but you may not want to use your brush pens on the textured paper since it may cause them to fray sooner. I used the Tombow Dual Brush pens for this project because I can use the fine tips to lay the ink down without worrying about fraying my brush tips. Crayola markers also will work great because they won't fray on the textured paper.

YOU'LL NEED

Pencil

Eraser

Mix media or watercolor paper

Water brush or paint brush

Jar of water

Paper towel

White or gold gel pen

Five water-based pens in galaxy colors: purple, blue, teal, pink, and black

1. Letter the quote in pencil.
First, letter the word in pencil and erase any pencil lines inside the downstrokes.

2. Outline the word.
Outline the word with a color that you don't mind blending with the galaxy colors (I don't use black here because I find it overpowers other colors).

3. Color in a downstroke.
Working one downstroke at a time, color in the downstroke sections with the different colors. (I like to vary the colors throughout the word so it looks like the galaxy has random spots of color). You may want to do a test of your blends first so you know how well each color blends together. (Avoid mixing pink and teal. If you mix complementary colors, they will turn brown and muddy).

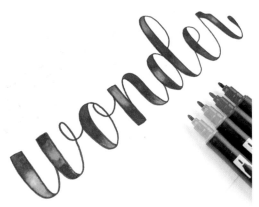

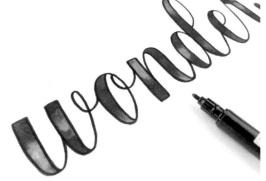

4. Use a water brush to blend the inks.
Working quickly so the inks don't dry, use a water brush or wet paint brush to blend the colors. Start by blending two colors at a time to get an even blend, then clean the brush on the paper towel and proceed to the next two colors, continuing until you've blended the entire downstroke. (Note that if the wet brush touches a watercolor that has already dried, it will leave hard lines. That technique may work if you are going for a cloudy look with a lot of hard lines.)

5. Continue with the remaining letters.
Continue the blending process with the remaining letters, varying where you place the colors in each letter.

6. Outline the word in black.
Once the inks have dried, use a black fine point pen to outline the galaxy letters.

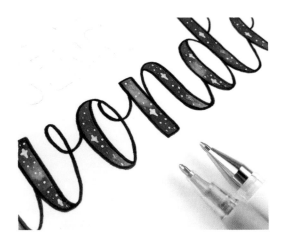

7. Add stars.
After the galaxy lettering has dried completely, use a white or gold gel pen to add stars. Use a black fine point pen to letter the remaining words in the piece.

GET CREATIVE

You also can perform this technique using other colors to create an ombré or rainbow blend. To create an ombré look, place the colors in the same positions for each letter instead of varying them.

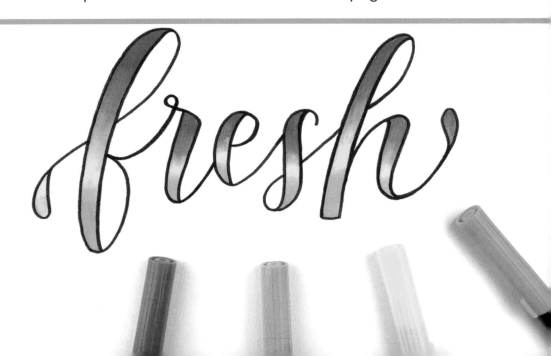

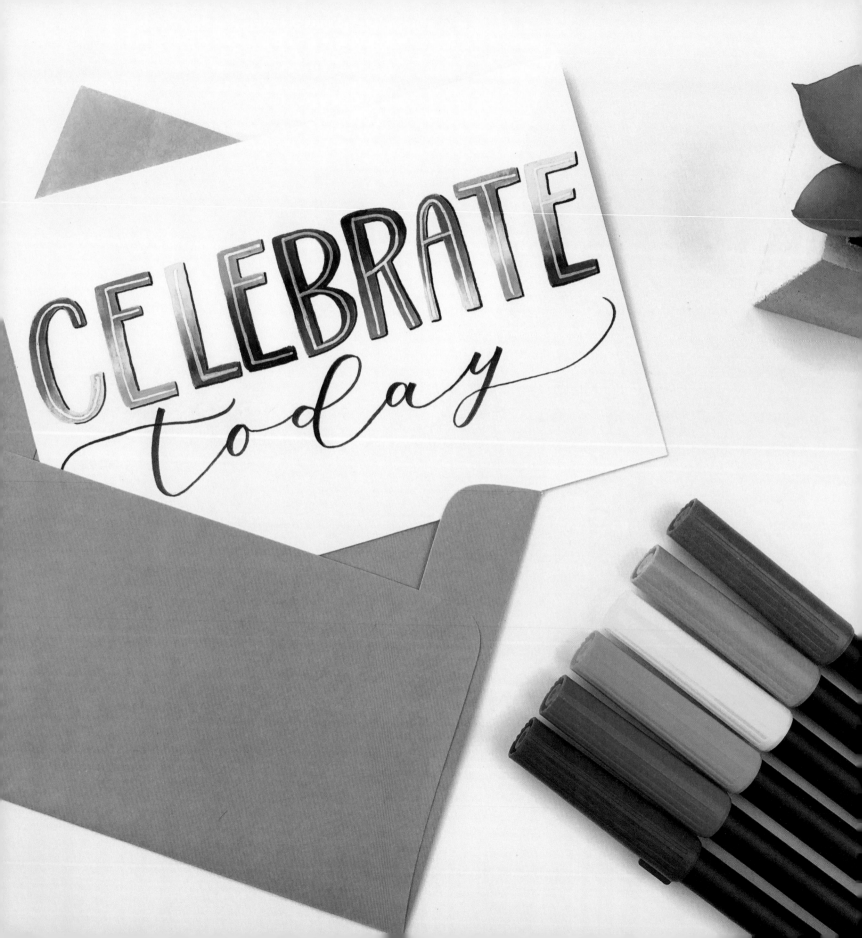

Print Style

After a regular script style, this is the style I most like to use—it's bold and a little quirky, and it can stand out in a quote. It also pairs well with a script style since it's made up of straight lines, which can add a nice contrast to curvy lines. You can choose how thick you want the downstrokes. By using a large, thick brush marker, you can get a chunky look, or you can get a more basic look by using a small brush marker.

Aa Bb Cc Dd Ee Ff
Gg Hh Ii Jj Kk
Ll Mm Nn Oo Pp
Qq Rr Ss Tt Uu
Vv Ww Xx Yy Zz

Practice the print style font by tracing or practicing in the practice worksheets. This style works best with small brush pens, but you can practice with large brush pens on your own paper to see how thick you prefer your downstrokes.

Aa Aa Aa Aa

Bb Bb Bb Bb

Cc Cc Cc Cc

Dd Dd Dd Dd

Ee Ee Ee Ee

Ff Ff Ff Ff

Gg Gg Gg Gg

Hh Hh Hh Hh

Ii Ii Ii Ii

Jj Jj Jj Jj

Kk Kk Kk Kk

Ll Ll Ll Ll

M m M m M m M m

N n N n N n N n

O o O o O o O o

P p P p P p P p

Q q Q q Q q Q q

R r R r R r R r

S s S s S s S s

Tt Tt Tt Tt

Uu Uu Uu Uu

Vv Vv Vv Vv

Ww Ww Ww Ww

Xx Xx Xx Xx

Yy Yy Yy Yy

Zz Zz Zz Zz

PROJECT Greeting Card With Rainbow Letters

One fun aspect of hand lettering is customizing your own greeting cards! I like to use a print style for this technique because it's easier to blend the colors one letter at a time, instead of trying to blend colors in an entire word. I used three colors for each letter in this project, but you can experiment. You'll want to use a card-sized smooth paper like smooth bristol or marker paper because you'll be blending the brush pens directly on the paper.

YOU'LL NEED

Pencil

Eraser

Very light-colored brush pen, such as light gray

Card-sized smooth paper

Scratch paper (to clean your pens)

Water-based brush pens in rainbow colors: pink, orange, yellow, green, blue, and purple

White gel pen

Small black brush pen

1. Sketch the word in pencil.
First, lightly sketch the word in pencil and then go over it with a very light-colored brush pen.

2. Add the first colors.
Add the first color to fill in the top section of the letter, then add the second color below the first.

3. Blend the darker color into the lighter color.
Using the lighter color of the two, pull the darker color onto the lighter color to create a smooth blend. (If you get a harsh line, you may need to go back with the darker color and pull it into the lighter color until it's smooth.) Continue this process throughout the word. When your brush pen becomes too saturated with the darker color, clean the ink off the pen by scribbling it on the scratch paper.

4. Continue blending.
Continue the blending process for each letter, varying the colors in each letter to create a unique effect.

5. Use a white gel pen to add a white line to the center of each letter.
Once the inks in the word are dry, use the white gel pen to add a white line in the center of each letter.

6. Add a shadow to each letter.
Use the small black brush pen to add a shadow to each letter by adding a line to the right sides and bottoms of each letter. (This will help your letters stand out.)

7. Fill in the script word.
Use the small black brush pen to fill in the script word.

GET CREATIVE

You can also use a water brush or wet paint brush to blend each color. This will create a slightly softer look since you'll be adding water, instead of more ink, to each blend.

every
day
is a
fresh
start

Elegant Script

This classy style features delicate strokes—it's a modern, elegant style that is open and widely spaced to give the feeling of a breath of fresh air. It's best created using a small brush pen. Using a large brush pen could result in too thick of downstrokes, which would be more of a chunky style and not what we want for this style.

A a B b C c D d E e F f

G g H h I i J j K k

L l M m N n O o P p

Q q R r S s T t U u

V v W w X x Y y Z z

Practice the elegant script font by using a small brush pen to practice directly in these worksheets or by tracing them onto your own practice paper. Because the strokes are elongated, you'll be moving your hand more, so you'll want to have plenty of room to work so you can move your arm and not just your hand.

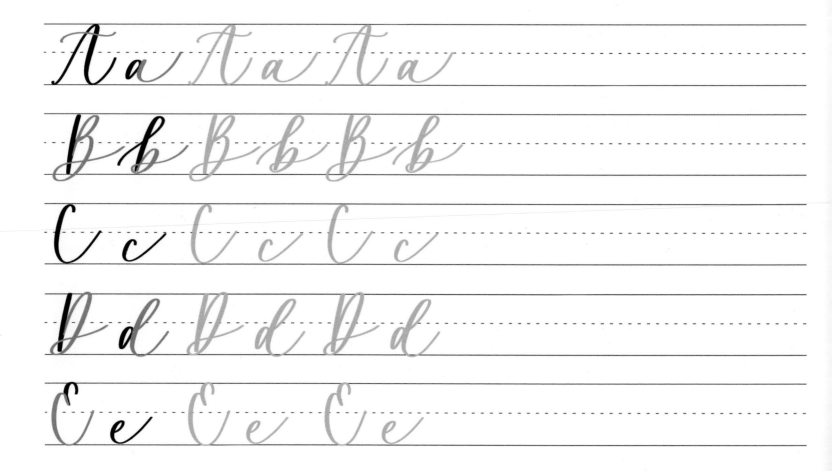

Ff Ff Ff Ff

Gg Gg Gg Gg

Hh Hh Hh Hh

Ii Ii Ii Ii

Jj Jj Jj Jj

Kk Kk Kk Kk

Ll Ll Ll Ll

M m M m M m

N n N n N n

O o O o O o

P p P p P p

Q q Q q Q q

R r R r R r

S s S s S s

Tt Tt Tt Tt Tt

Uu Uu Uu Uu

Vv Vv Vv Vv

Ww Ww Ww Ww

Xx Xx Xx Xx

Yy Yy Yy Yy

Zz Zz Zz Zz

PROJECT Inspirational Desk Placard with Ombré Lettering

The ombré technique is the simplest way to blend brush pen colors and create a beautiful effect. You can accomplish this technique using any size brush pens, and you can use large brush pens if you want thicker downstrokes for a slightly chunkier look. Use a smooth paper to avoid fraying your brush pens and experiment with different colors to see what unique blends you can create!

YOU'LL NEED

Smooth paper in desk placard size

A palette (or glass or plastic surface)

Scratch paper (for cleaning your pens)

Brush pens in rainbow colors: red, orange, yellow, green, blue, and purple

1. Lay down the dark ink first.
Choose the first two colors that you want to blend. Lay down some of the darker ink on the palette first by scribbling the brush pen on the palette.

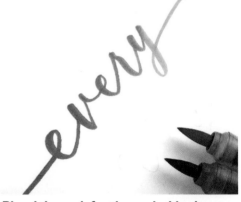

2. Blend through for the ombré look.
Swipe through the darker ink with the lighter-colored pen and then start lettering on the paper. The added ink will gradually wear off as you letter and create the ombré look, and you can swipe through a few times to add more ink, depending on how much of the color you want.

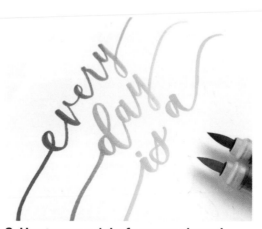

3. Use two new inks for second word.
Continue this process with the second word, again using two new ink colors but creating a unique single blend for each word.

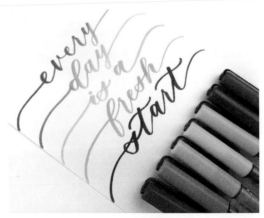

4. Continue until finished.
Continue the blending process with the rest of the words, using a single blend for each word.

GET CREATIVE

You can also blend two brush pens by lightly pressing the tips of the pens together for a few seconds to transfer the ink. When the ink is just on the very tips of the pens, you can create a cool striped effect. Be sure to touch the tips together between each letter so the ink doesn't wear off by the end of the word.

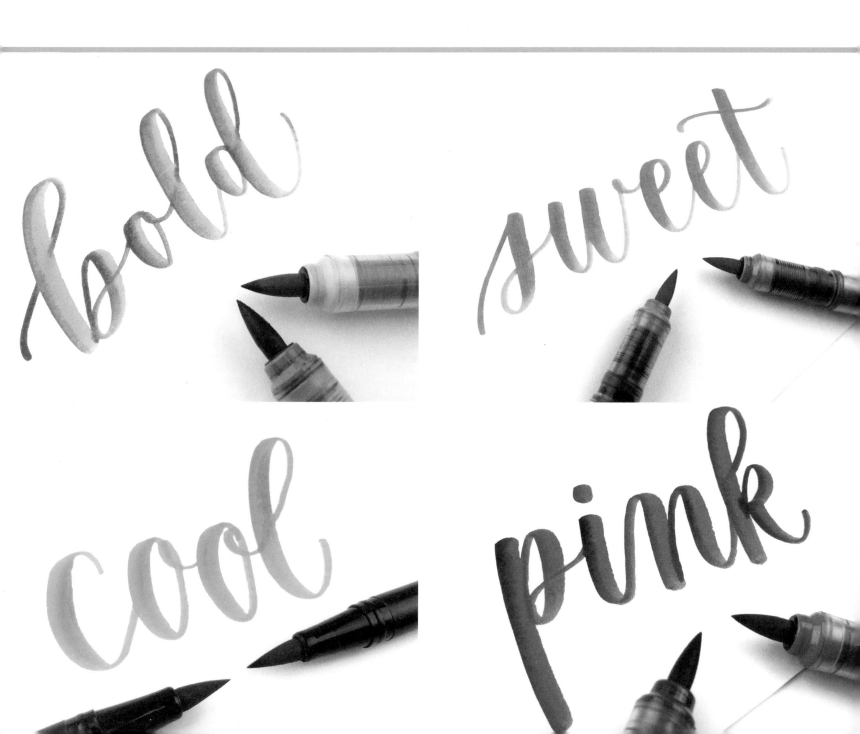

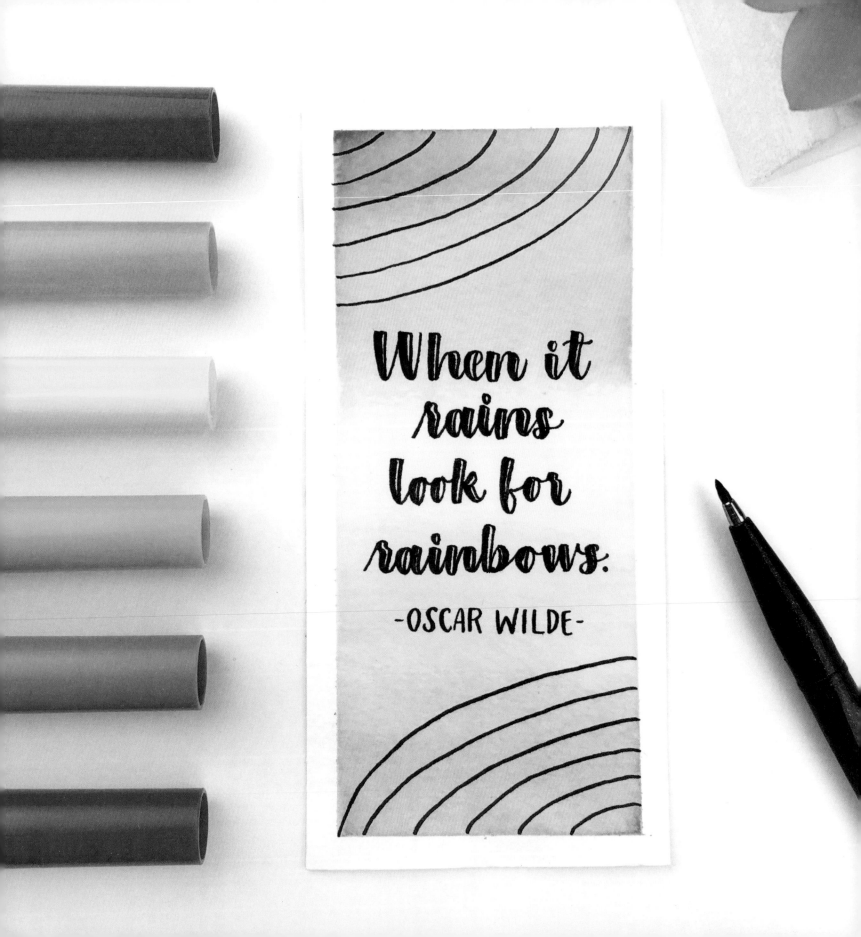

Brush Pen Faux Calligraphy

This font is fun and will add something extra to your letters! It's great when you want to use a simple technique that will make your letters stand out. This style is created by adding an extra line to the downstrokes with a brush pen, as if it was faux calligraphy, but you'll leave the strokes open instead of filling them in.

Aa Bb Cc Dd Ee Ff

Gg Hh Ii Jj Kk

Ll Mm Nn Oo Pp

Qq Rr Ss Tt Uu

Vv Ww Xx Yy Zz

Practice brush pen faux calligraphy by tracing or practicing in these worksheets. First letter your thick downstroke as you normally would with brush pen lettering, then add the thin line to the sides of the downstrokes. It takes a steady hand to create those thin strokes with the brush pen, so take your time. These worksheets work best with a small brush pen.

Aa Aa Aa

Bb Bb Bb

Cc Cc Cc

Dd Dd Dd

Ee Ee Ee

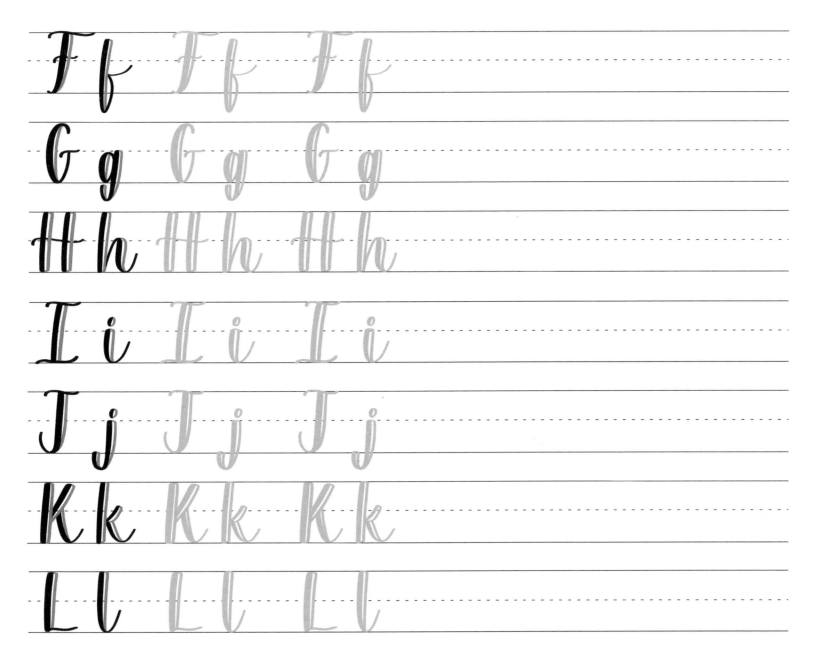

Mm Mm Mm

Nn Nn Nn

Oo Oo Oo

Pp Pp Pp

Qq Qq Qq

Rr Rr Rr

Ss Ss Ss

Tt Tt Tt Tt

Uu Uu Uu

Vv Vv Vv

Ww Ww Ww

Xx Xx Xx

Yy Yy Yy

Zz Zz Zz

PROJECT Watercolor Rainbow Bookmark

This rainbow background is one of my favorite ways to add color to my lettering projects. It's so simple and you can use any water-based brush pens or markers instead of watercolors. In this project, I used Crayola markers to create the rainbow blend. It looks good when paired with any style of lettering, but it looks especially nice when paired with letters created in solid black.

YOU'LL NEED

Watercolor paper cut to bookmark size

Water-based brush pens in rainbow colors

Paint palette (or glass or plastic surface)

Water brush or paint brush

Jar of clean water

Paper towel

Small black brush pen

Wide washi tape

1. Tape down the paper.
First, tape down the watercolor paper with the washi tape to help create a clean, straight edge for the rainbow. (You can skip this step if you prefer rougher watercolor edges.)

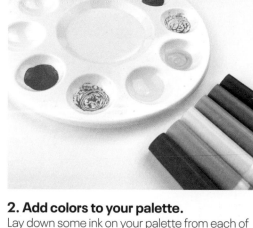

2. Add colors to your palette.
Lay down some ink on your palette from each of the brush marker colors. (If you don't have a paint palette, you can also use a plate.) Make sure there is plenty of ink on the palette.

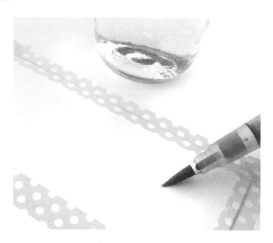

3. Wet the paper surface.
Use the water brush or a wet paint brush to coat the entire surface of the bookmark with clean water. (This is called a "wet-on-wet" technique because we are adding wet ink to a wet surface.)

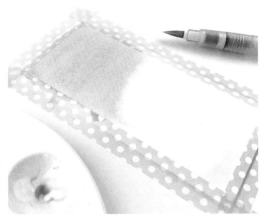

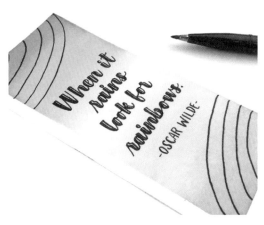

4. Start blending the first two colors.
Pick up the first color with the water brush and add it to the top of the bookmark, then clean the brush on the paper towel and add the second color just below the first while carefully blending the colors together. (For a smooth blend, you may need to use a clean brush to go from the top of the second color to the bottom of the first.)

5. Continue with the remaining colors.
Working quickly so the bookmark stays wet, continue the blending process with the remaining the colors, making sure to clean the brush between each color and only blending two colors at a time. (If the paper dries out, you will get hard watercolor lines.)

6. Add the quote once the paper is dry.
After the bookmark is dry, use the small black brush pen to add your lettering. You can lightly pencil sketch the quote first, unless you want to freehand it. Gently erase any pencil marks once the lettering is dry.

GET CREATIVE

For a unique look, use narrow washi tape to create geometric lines in the rainbow background.

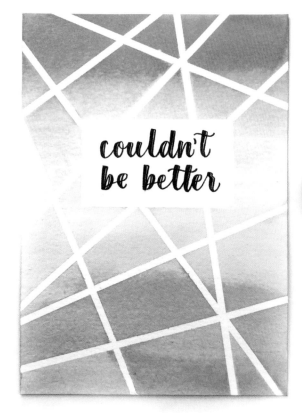

Index